Understanding
RAW
Photography

Understanding
RAW
Photography

Andy Rouse

photographers'
pip
institute press

First published 2007 by
Photographers' Institute Press / PIP
an imprint of The Guild of Master Craftsman Publications Ltd, 166 High Street, Lewes, East Sussex, BN7 1XU

ISBN 978-1-86108-515-3

British Cataloguing in Publication Data. A catalogue record of this book is available from the British Library.

Production Manager: Jim Bulley
Managing Editor: Gerrie Purcell
Photography Books Project Editor: James Beattie
Managing Art Editor: Gilda Pacitti
Designed by Fineline Studios

Typeface: Myriad

Colour reproduction by Altaimage
Printed and bound:
Hing Yip Printing Co. Ltd

Contents

1

2

3

4

5

6

Welcome to the wonderful world of RAW photography!
For some people this book will serve as a refresher, with
some useful insights along the way, while for others it will
change the way you photograph forever. *Understanding RAW
Photography* has been written as the natural successor to the
incredibly successful *Digital SLR Masterclass*, which, according
to the correspondence received by both myself and the
publisher, helped a great many photographers get started
with their new DSLR.

Introduction: why shoot RAW

You don't have to have read *Digital SLR Masterclass* to make sense of this book, but some of the elements that were particularly well received, such as the 'pro tips' and the 'bottom line' boxes are used here alongside some new features, to make the RAW process even easier to understand.

While *Digital SLR Masterclass* was written for those taking their first steps with a DSLR, *Understanding RAW Photography* is targeted primarily at the hobby photographer who takes pictures for fun, but cares about them deeply enough to want to get the best quality. These photographers are generally constrained by time, with family and work pressures pushing photography into a distant third place. However, this book is not just for novices – although the concepts are explained in an easy-to-follow fashion – experienced photographers can also gain a lot from it. It contains all the latest developments, alongside plenty of hints and tips from years of experience as a professional photographer. This book is intended to be a great leveller when it comes to knowledge about RAW, and therefore if you are experienced with RAW, and comfortable with why you are shooting it, then please skip ahead to chapter one. If you've just picked up this book and are wondering what RAW is and whether it is suitable for you and your photography, then read on.

So what is RAW? Simply speaking it is one of several formats that your digital camera is capable of storing your pictures in. The other main one is JPEG of course, and most photographers reading this book will probably have their camera set to JPEG right now; traditionally it has been the format of choice because RAW has been seen as incredibly time-consuming and the domain of the more technically minded and professionals. In recent times, however, this has changed, with both the media and opinion formers beginning to extol the features of RAW over JPEG. So why should you consider shooting RAW instead of JPEG? The answer, which could run into pages if we let it, is mainly one of flexibility, with a few quality issues thrown in as well.

Let's deal with a common misconception first: that a RAW image is much better quality than a JPEG. The main quality difference between the two formats is the compression that happens when your digital camera saves your image to a storage card; a JPEG is a compressed file whereas a RAW file (in most cases) contains the pure uncompressed image data. In essence, this means that the JPEG has lost some of the original image data through compression, the more it

Right *The end result of the workflow, an image that you will be proud to show everyone!*

is compressed, the more data is discarded – one of the reasons why JPEG files are so much smaller in size than RAWs. Whether this loss of data causes the JPEG to be visually inferior to the RAW file is subject to debate and I have made a number of tests that demonstrate that, although on paper there should be a difference, in reality there is very little visible difference. The main difference in the quality is that a RAW file has more dynamic range than a JPEG, which cannot be directly seen. But when you start to make colour corrections to your images, you will soon see that a RAW file simply has more tones to play with and therefore you can correct them with a higher degree of accuracy and control. The only sure-fire visible difference occurs

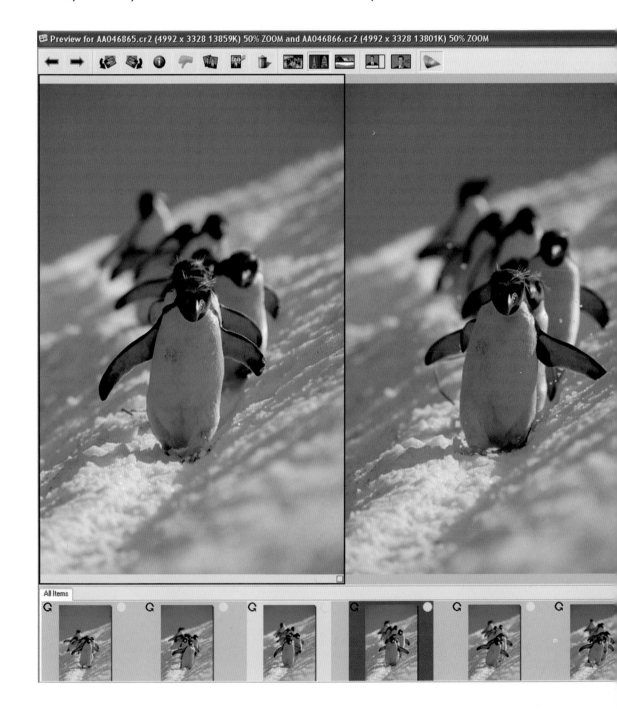

Preview for AA046865.cr2 (4992 x 3328 13859K) 50% ZOOM and AA046866.cr2 (4992 x 3328 13801K) 50% ZOOM

in certain conditions such as low light, when the JPEG compression gives rise to banding and accentuated noise; this will not occur in a RAW file taken in the same conditions.

In terms of flexibility, there is a big difference between RAW and JPEG although the non-destructive editing now possible of JPEGs through Lightroom and Aperture has blurred this boundary somewhat. When a JPEG image is recorded, the camera applies certain parameters such as colour, white balance, sharpening and saturation directly into the file; making any changes to these parameters generally requires in-depth knowledge of image-editing software such as Photoshop. Even the new generation of tools such as LightRoom and Aperture is only able to edit the final JPEG file out of the camera and while they can make changes to white balance, saturation and such parameters, these changes are applied on top of the original ones. In other words the JPEG is being saved again, which will result in more compression and more potential data loss.

A RAW file, on the other hand, has the same parameters recorded at the time of shooting, but does not apply them to the RAW file. Instead they are kept as an external parameter set that is accessed every time the RAW file is viewed. Therefore the great thing about RAW files is that since these parameters are not applied to the image data itself, they can be easily changed using specialized RAW software with no more knowledge than the ability to use a mouse. In fact, a RAW file can undergo miraculous changes in the course of just a few clicks, without any degradation to its appearance or quality.

RAW files are also very forgiving of exposure errors and images that are under- or overexposed can often be recovered to a large degree into attractive and workable images. One fact never changes though, the original RAW file remains unchanged throughout all of this processing, as it is the parameters in the external parameter set that are changed. This means that the RAW file is a record of what you actually shot, which is especially important in some areas of photography.

Shooting RAW will give you the confidence to experiment and try new things; remember photography is not just a technical skill, it is a means of self-expression. You will be reminded of this throughout the book as it is easy to become obsessed with gadgets and technology.

Left *A good workflow is essential for allowing you to pick out the winning images from ones that initially might look similar.*

In the field
- ▶ Exposure decisions
- ▶ File decisions
- ▶ Practical considerations

Initial editing
- ▶ File transfer
- ▶ Basic editing
- ▶ Editing similar files

Basic corrections
- ▶ Exposure
- ▶ Dust
- ▶ Cropping

The RAW workflow

The most important thing that you need to understand about RAW photography is the need for a rigorous workflow. This underpins every stage of the process, from before you even release the shutter, through the editing, processing and correction stages, to the final cataloguing and output of your images; understanding the importance of a good workflow will help you to enjoy your photography and make full use of the potential of RAW.

Advanced corrections

- ▶ Advanced colour
- ▶ Sharpening

Management & storage

- ▶ Choosing or creating a file management system
- ▶ Storage considerations

The end product

- ▶ Displaying images
- ▶ Printing images

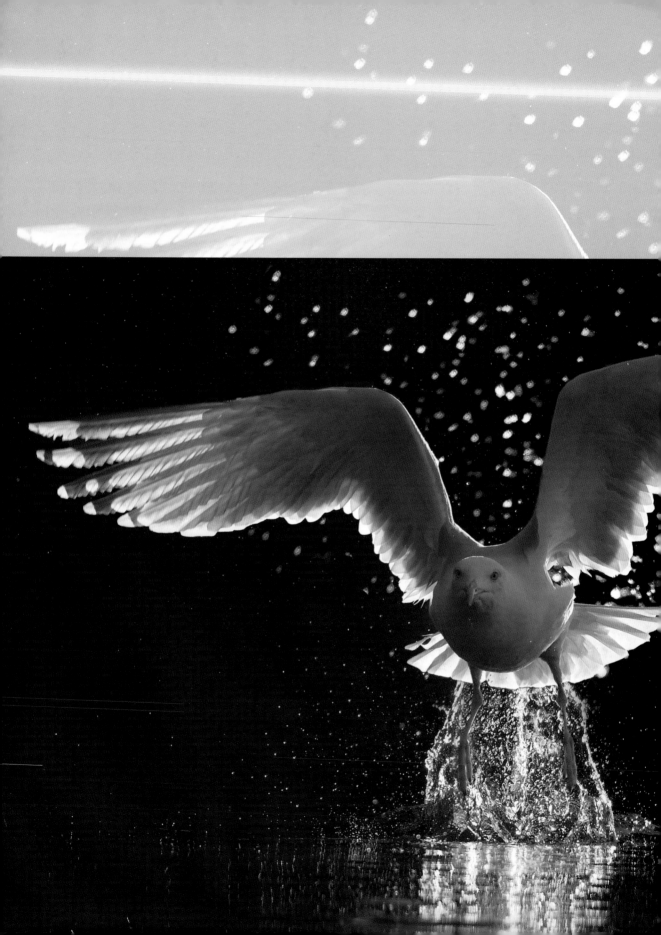

Workflow overview

And so we begin the book in earnest, with a chapter that sets the scene for what is to come. This book follows a very simple RAW workflow strategy that will be applicable to most photographers who read this book, but it should not be considered as the only show in town; it is a starting point and one which you can modify to meet your own needs. The RAW workflow comprises these four different building blocks:

Workflow overview

No matter which level of photographer you are, from novice to professional, you will always encounter these four building blocks. The logical progression is Camera set-up > Editing > Correction > Management and each section is explained as follows:

Camera set-up

The workflow starts before you even take your first RAW picture, as so much that you do at this stage has an impact on what you do later. The second chapter of this book deals with setting up your digital camera, exposure techniques for digital cameras to allow you to use their unique features to their full potential in the field. This also covers aspects of your camera such as sensor cleaning, storage and how to maximize your chances of getting the shot that you actually want.

Editing

The RAW files you shoot will contain a huge mixture: some will be underexposed or overexposed, while others will be perfectly exposed, there will be missed opportunities, out-of-focus shots, sequences that are identical in seemingly every way, and so on. This workflow will look at how to edit these files down to a manageable number (saving disk space and time) picking out the ones to keep, and from these the ones that you will actually correct. While it is everyone's intention to correct all edited RAW files, in reality your time is all too often limited, and therefore it is important that you are able to prioritize your work, concentrating on the best images.

Correction

All RAW files will require some level of colour correction, and some will need formatting changes (such as cropping) to improve their composition. For most RAW files this will be enough, but there will be some photographers who need additional tools to perform more complex levels of processing. Chapter 4 will look at some of the basic correction tools, and will suggest a few approaches to making corrections to your RAW files. Once all of your edited RAW files have been corrected, the various options for backing up your files to keep them safe will be discussed, before moving on to consider what to do with them. The chapter will look at various output workflows, such as printing from RAW, a very clever and space-saving proofing workflow and creating a high-resolution file for distribution or further processing.

Management

Perhaps the greatest challenge in the RAW workflow is that of managing your images, both in terms of any RAW files and other output files that you may have created. Management means organization, grouping your images so that they mean something to you and that you can find them quickly when needed.

Q What is a workflow?

A A workflow is a series of logical steps to get from A to B in the most efficient way. In terms of this book, a RAW workflow is the series of steps that takes you from the RAW images in your digital camera to the finished product, in other words a print, a web gallery or a hi-res file for distribution. To be honest, much of what follows is common sense, and once you get the hang of why certain things are completed at certain times, everything will become clear. A workflow is just a process, in fact it is a mindset and a determination to find the best images that you have taken and to show them off to all and sundry; that is what a good workflow helps you achieve. There is no right or wrong workflow and you should not believe otherwise; there is just the workflow that is best for you.

And that is it! Of course this workflow is just one of many possibilities, and it can be modified according to your own personal needs. Before you do this, of course, you need to consider what software you are going to use to actually help you complete the workflow in the first place.

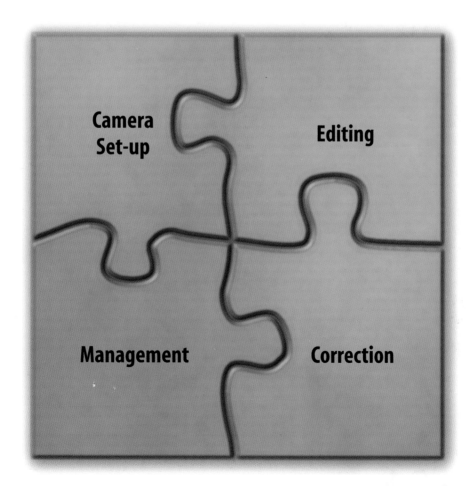

Software choices

The choice of software is as important as that of the digital camera itself, as it can make or break a workflow. Software comes in two forms, proprietary programs supplied by your camera manufacturer (usually for free) and third-party programs, distributed by a wealth of independent software houses such as Adobe, Apple, Microsoft, PhaseOne, DxO, ACDSee and so on. Even Google have got in on the act with its excellent Picasa2 software. This book will concentrate on independent software, as this tends to offer the best solution for keen photographers; however, all of this software performs at least one, although sometimes more, of the following functions, and progressively more programs are promising to offer all of these under one umbrella.

Below *Some digital asset management applications such as Google's free Picasa2 also offer complex correction options for your RAW files. This image of a cheetah cub is being enhanced by a Soft Focus filter that would be hard to recreate manually.*

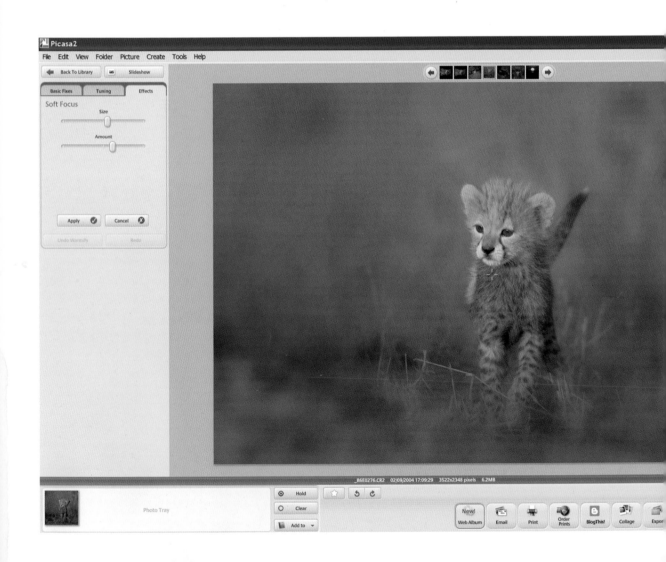

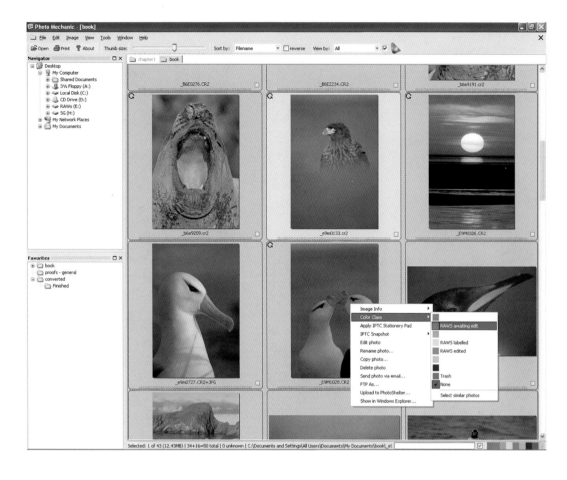

RAW downloaders

As the name implies, these allow you to download your unedited RAW files from a camera or external device to your workstation, without having to go near the operating system. Usually they can perform additional functions, such as applying set instructions for dealing with duplicate file names, or renaming files and some even perform keywording and catalogue operations.

RAW browsers

These applications display the RAW files in a particular location and allow various management tasks to be performed on each file or group of files (such as moving, copying, renaming or deleting) as well as having options for full screen slideshows, assigning ratings or priorities and all kinds of great stuff. The best ones also display other file formats too, such as TIFF and JPEG.

Above *Image browsers come in all shapes and sizes and allow you to perform many functions of the workflow from a visual perspective. Here RAWs are being colour coded right at the start of the workflow.*

RAW correction software

Located at the centre of the RAW workflow, these applications are becoming increasingly sophisticated in the colour and other corrections that they enable you to make to your RAW files, without any degree of technical knowledge. All changes are seen instantly on a preview screen, can be modified at any time without affecting the RAW file, and the best ones provide all the correction tools that most photographers will ever need. They are becoming increasingly sophisticated and now include their own browsers, integrated printing and applications to manage and catalogue all your files.

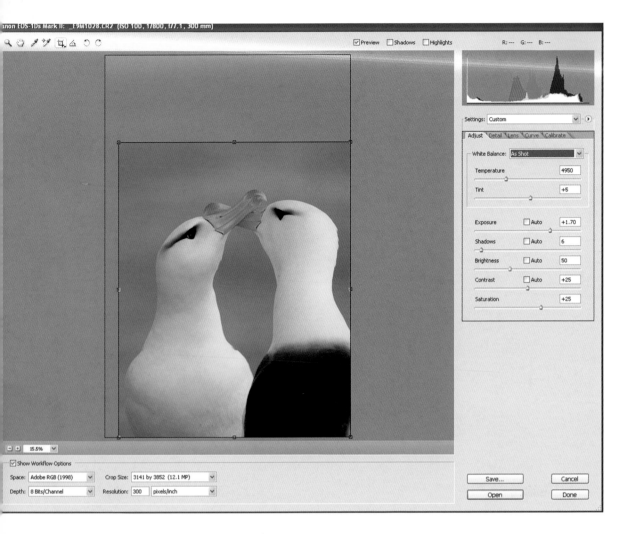

Post-processing software

This software is used to perform more localized corrections to a high-resolution file than is possible with the RAW correction software. Increasingly, however, the lines between the two types of software products are becoming less distinct, as more and more powerful features are appearing within RAW correction software, such as dust-spot removal, that provide what most users need.

Digital asset management (DAM) software

These are highly graphical and colourful applications that handle the cataloguing and general management tasks for all formats of digital files including RAW, TIFF and JPEG. In the past they have just been used for this

Above *Correction to RAW files does not just mean tweaking the colour, here a colour-corrected RAW file is being cropped to improve its composition. Most applications will allow you to do this, some with pre-assigned sizes and others with a 'do as you want' approach.*

purpose alone, but now they are packed with many of the features listed already. These applications, as you will see, are the future of the RAW workflow, as they can make the process both manageable and fun for all levels of photographer.

The products are all relatively simple to use in isolation, it is when they are used together to solve the problems of the RAW workflow that the really interesting work begins.

The 'separates' solution

Hi-fi buffs like to buy a separate amplifier, CD deck and tuner from different manufacturers and bolt them together to make a complete unit. Rather than settling for a hi-fi that comes complete from a single manufacturer, they like having the freedom to choose the best separate components on the market and integrate them into the ultimate sound system. The same is certainly true for RAW workflow software, and it is common practice to use different products from different manufacturers for each stage of the workflow. Image browsing and editing is carried out using products such as Adobe Bridge or BreezeBrowser, RAW conversion is handled by Adobe's Camera RAW, C1 Pro or something similar, Photoshop or Paint Shop Pro are used for any post-processing of high-resolution files; and a DAM application such as Adobe Bridge, iView or Picasa2 is used to bring it all together.

The 'all-in-one' solution

These products are relatively new to the market, and are intended to provide all the functionality for the RAW workflow that most users need. They cover all of the bases including downloading, browsing, file management, slideshows, editing, back-up, renaming, colour and format correction, output management and finally cataloguing. There has been a huge demand, particularly from professional photographers, for this kind of all-in-one application and at the time of writing there are several different applications available to the photographer. Adobe's Photoshop Lightroom and Apple's Aperture are the two main programs, and both are targeted primarily at the

Below *A basic RAW conversion screen with the scalable preview image and the simple correction sliders on the right.*

professional and enthusiastic amateur markets. These applications are very sophisticated and provide an amazing array of correction and output tools including direct printing from RAW files. Expression Media and Google's Picasa2 take a different and more visually led approach; they provide much of the same functionality as the previous two applications, but are also designed to integrate with other RAW software if necessary. The latter products have their roots in Digital Asset Management and, as such, are much more graphical in their nature with their emphasis on ease of use.

Right *DAM applications are brilliant for managing the workflow and giving an overview of the status of a collection of images. Using keywords or search fields, or a combination of both, alongside other functions, they make it simple to find images when you need them.*

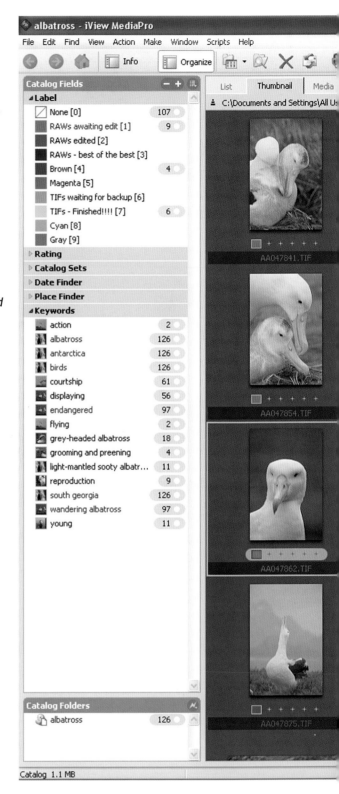

Jargon busting

Before we begin to look at individual parts of the workflow in earnest, some basic terms need to be explained first.

Operating systems

Even though the screengrabs mostly show software running in a Windows environment, I have no bias towards Windows-based computers or Macs. In fact the RAW workflow is platform independent and the majority of software applications are available for both platforms, although there are some notable exceptions such as Apple's Aperture program.

RAW

There is no single RAW format, rather a collection of different manufacturers' proprietary formats; for example, these include .cr2 (Canon), .nef (Nikon), .orf (Olympus), .pef (Pentax) and .srf (Sony). While these are all different file types, they do what is essentially the same job and contain raw rather than processed data from the camera's sensor. While a manufacturer's own software may only provide compatibility with a single file type, third-party software should be able to work with the vast majority of RAW formats.

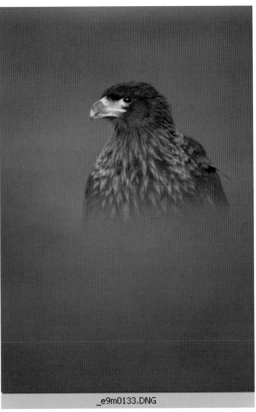

_e9m0133.DNG

_e9m0133.CR2

Above and Left *A graphic example of the advantages of DNG. The file on the left shows the RAW file as the browser sees it, even after colour correction whilst the one on the right is the DNG file. The colour correction has been deliberately overemphasized to make the comparison clearer.*

Adobe DNG

 While most RAW formats are proprietary, Adobe's DNG (Digital Negative) is a standard RAW format that has been released to address certain problems. As DNG has the potential to revolutionize the RAW workflow, it has been included throughout this book alongside the more common RAW formats. The DNG format aims to address the following issues:

An open standard RAW files from Canon and Nikon cameras are supported by all major RAW applications, but the same cannot be said for every digital camera. It can be a frustrating process to find that your new camera's format is only supported by proprietary software (which is often not very good). DNG solves this by providing a well-documented and supported RAW format, which manufacturers can adopt as their standard RAW format. This means that photographers using these cameras can have their choice of RAW format (in other words manufacturer's RAW or DNG) and by choosing DNG they should have access to a wider range of software ... as long as it supports DNG.

DNG converters Adobe has made it easy to convert your RAW files into DNG without waiting for the camera manufacturer to give you this option. The converter supports a wide variety of RAW formats and it can be downloaded for free from the Adobe website. Some software applications like BreezeBrowser Pro provide an integrated DNG converter for your RAW files and add some functionality and support for certain cameras, such as recording the autofocus points.

Management You will see later how backing up a RAW file sometimes involves not only backing up the file itself, but also an external colour file. DNG solves this by keeping all of its information within the DNG file itself, so you only ever have one file to worry about.

DAM issues Digital asset management is becoming increasingly important to all levels of photographer, and some photographers like to catalogue their RAW files to integrate the DAM system fully into their RAW workflows

(see chapter 6). In practice this can work well except that DAM applications rarely support any kind of external colour file; this means that you will not be able to view your RAW file with its colour corrections in all its glory, it will always look as you shot it. As just a few clicks in any RAW software can make an amazing difference to any shot, it seems a shame not to display the corrected RAW file. A DNG file, on the other hand, will always display the colour corrections as they are embedded within the file itself, therefore all the colour changes will be displayed in your DAM application, as long as it supports DNG.

DNG also gives the photographer the option to save the original RAW file within the DNG file itself. This effectively doubles the size of the file and is intended to ease the transition to DNG for photographers who are wary of adopting an unproven format.

To be successful DNG needs to be accepted by both camera manufacturers and RAW software producers; at the time of writing, it is gradually being accepted by both. If it does become widely accepted then, once you have the DNG file, the original RAW file is redundant; if you are cautious then back-up the RAW file in case and just use the DNG file.

There is no doubt in my mind that the DNG format should be good thing for photography and can only improve your workflow. At the time of writing, RAW software manufacturers are gradually supporting the format, and it will be this that determines whether it is fully adopted. The signs are good, however, and for this reason DNG has been included, with any of the advantages offered highlighted where relevant.

 PRO Tip

At the time of writing, I have just started to consider integrating DNG into my workflow, but I use RAW software that does not, and for various reasons, will never fully support DNG. Therefore I will have to move to a new RAW platform if I want to use DNG, and I will probably have done so by the time you are reading this.

Digital camera

Throughout the text you will see the term 'digital camera' when you might have expected to see DSLR. This reflects the emergence of the digital compact camera as a popular choice for many serious digital photographers; many of these now offer RAW as well as JPEG. In fact, I use a Leica digital compact camera, alongside my DSLRs, which records a 10-megapixel RAW file that would compete with those from many DSLRs.

Metadata

When you take any pictures with your digital camera, a unique set of data is created for each shot that is called EXIF (Exchangeable Image File Format) data. This contains such useful information as camera type, shutter speed, aperture, ISO setting, white balance, date and time of shot, plus much, much more. In fact it has everything that you ever wanted to know about the shot, and it is stored within the RAW file itself. Image browsers and RAW software can extract metadata from a RAW file and display it whenever you request it. Metadata is a useful tool, but it is Adobe's additional XMP (Extensible Metadata Platform) metadata that really makes a difference. XMP metadata is modifiable and contains vital information about the image itself, such as who shot it, who owns

the copyright, what the image actually shows, a rating to show how good it is and keywords to describe it. You can think of it as a digital business card that accompanies your image wherever it goes. When combined with EXIF metadata, you have a very useful amount of information about the image. Originally XMP metadata was only modifiable through the 'File Info' dialogue box in Photoshop, but now Adobe, working with the IPTC standards body, has made it a lot more open and other software applications are able to work with XMP metadata. This means that the data can be passed between different applications from different software providers.

How to use this book

So that takes care of all the basics, now it is time to get down to the nitty-gritty of the workflow. A RAW workflow is a very complex subject to explain, not because it is difficult, but purely because there are so many variations and personal preferences. Therefore chapters 2,3,4 and 5 provide building blocks for the RAW workflow, essential information that you can use no matter which software product you use. Chapter 6 brings the story all together and shows how a digital asset management solution can help you manage the entire workflow from a single product. This does not mean of course that these kind of tools can do everything that you need, they cannot, but they provide a great overview of the RAW workflow within which other products can be integrated. If you are completely new to digital photography, then you might want to read chapter 6 first to get an overview before launching into the specifics of each workflow step. Otherwise the book will take you through in a logical, step-by-step fashion.

PRO Tip

I use XMP metadata all the time to caption my images for submission to agencies and clients worldwide. Every image that I send out has my full copyright details, as well as full details about what the picture actually shows, in other words the species name, scientific name and location. The great thing is that if I am labelling a group of images showing a similar subject, I have no need to enter the same information each time. I just type in all the information into the first file, save this as a metadata template, and apply it to all the others. Brilliant and time saving!

Calibration

I have included this section to answer one of the
questions that I am asked most often: 'why do my
prints look different from the image on screen?' It is
a problem that troubles everyone and it is pointless
going through all the workflow in this book if you
cannot get a decent print at the end of it. Fortunately
it has a simple, if sometimes expensive, solution.

Step one

All devices see colour slightly differently, and all
monitors will have a slightly different colour bias.
Therefore the first task is to calibrate your monitor to
an accepted international colour standard so that what
you see on your monitor will match another calibrated
monitor exactly. It sounds difficult, but it is simply a
matter of getting specialized monitor calibration
software, attaching the supplied hardware device to
the monitor and making some adjustments when you
are prompted to. The end result is a monitor profile
that will be used by software applications like the RAW
converter to display consistent colours.

Step two

Now it is time to calibrate the printer; again specialized
software will do this for you and generate a printer
profile for a particular type of paper. This profile can
then be attached to the image before printing (called
soft proofing), so that the effect can be viewed on
screen. In theory what you see on screen will be what
you get from the printer, although you may need to
make a few tweaks here and there. If you can't be
bothered with all this, then many companies will
generate the profile for you in return for a small fee.

For many photographers, this will seem like a lot of
work and if you fall into this category then I would
suggest that the easiest route is to calibrate your
monitor using the free tools in your operating system
and then send the image to a reputable online lab for
printing. If they have good calibration, then the results
should be perfectly good enough; however, if you want
exact results every time, then you will have to go
through the process outlined above.

Left *Screen colorimeters
such as this ColorVision
DataColor Spyder2PRO
measure defined output
values from their associated
software and feed the
output from the screen back
to the software. It then
makes adjustments
to the output so that the
monitor is precisely
calibrated and shows true
colours (or as true as they
can be).*

In the field

Too many photographers assume that the RAW workflow only begins when the RAW files are on the workstation. Actually the workflow begins when you pick up a digital camera to take your shots; as how you set it up and use it can have a great effect on both the processing and the final quality of your images.

Digital camera set-up

This chapter starts with the basic camera set-up and then moves on to the much more complex subject of exposure for digital cameras. Follow these guidelines and you will not only capture images that will do your photography justice, but also you will save time sat in front of your workstation.

There is no doubt that the digital camera has had a negative effect on the skills of many photographers, and the attitude that 'I can correct any mistakes later'

is one that I hear more and more on the workshops that I run. Although most RAW software can seemingly correct an image that was poorly exposed, it cannot correct for out-of-focus images or awful composition. That is your responsibility as a photographer and so this chapter will deal with the basics of setting up a digital camera; concentrating on the end results, rather than the whys and the wherefores, as these can be found easily online or in other books.

Camera-specific settings

These settings are all to be found within LCD menus on the back of your digital camera. What they are called varies from one camera manufacturer to the next, but you will find that the following list covers the most common and those which can have the most effect on your photography.

Above and right *A couple of menu screens from a Canon DSLR that show just a few of the many options that are available on DSLRs and other digital cameras.*

Image format

This determines the format of the image from the digital camera that is written to the memory card. Depending on your camera manufacturer, there can be a combination of the following choices:

RAW A RAW file, the format of which will depend on the camera make and model (see page 22).

DNG Some manufacturers have added Adobe's DNG RAW format (see page 23) as an option alongside their own RAW formats. This is mainly because their RAW files may not be widely supported by software; the DNG option removes this limitation and allows the file to be processed in a wider range of RAW software, as well as enjoying the other benefits of DNG. Before setting this option, check that your chosen software supports DNG.

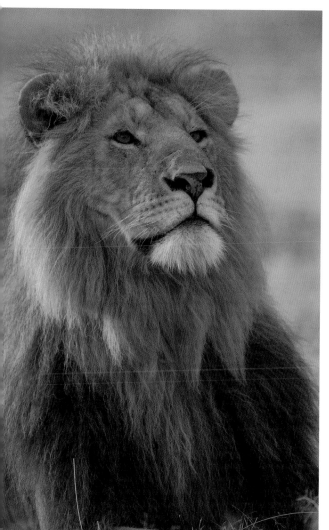

RAW + JPEG Many cameras offer the RAW + JPEG option and some like the Leica D-LUX3 have this as standard for their RAW settings. With this option set, the digital camera writes a JPEG (sometimes the size can be altered) to the storage media alongside the RAW file. The JPEG is usually big enough to give a decent screen image and is generally used by some RAW software for editing as it will be much quicker to load than a RAW file; it can also be viewed by operating system software as well. Most RAW software, however, is now fast enough to display RAW files in real time, hence viewing and editing the actual RAW file is common practice. Unless your RAW software needs to use the JPEG, or you need it for printing directly from camera or emailing, there is no point in setting the RAW + JPEG option; not saving the JPEG may allow a few more RAW files on a decent-sized storage card, and in my experience this can be crucial.

JPEG A far less flexible option than RAW, and, to be honest, if you are setting JPEG then you are reading the wrong book!

TIFF In my opinion this has been (and always will be) a completely pointless option, offering large file sizes with relatively little flexibility, and it is one that is being included on fewer and fewer cameras as time goes by.

White balance

There have been many discussions about the correct setting for white balance and to be honest it is not really worth all of the debate. Most digital cameras make a decent attempt at getting the white balance correct and in the vast majority of cases the white balance is spot on. It is only in difficult lighting conditions, such as indoors or in overcast lighting, when the digital camera might interpret the white balance incorrectly. This isn't a major problem, all that happens is that the image will have a colour cast, which is easily removed by a click or two using the RAW software white balance correction tool.

Left *African Lion (Panthera leo). A dominant male with scars from a pride takeover fight, Maasai Mara, Kenya. Note how careful use of the white balance function has retained warm tones in the image.*

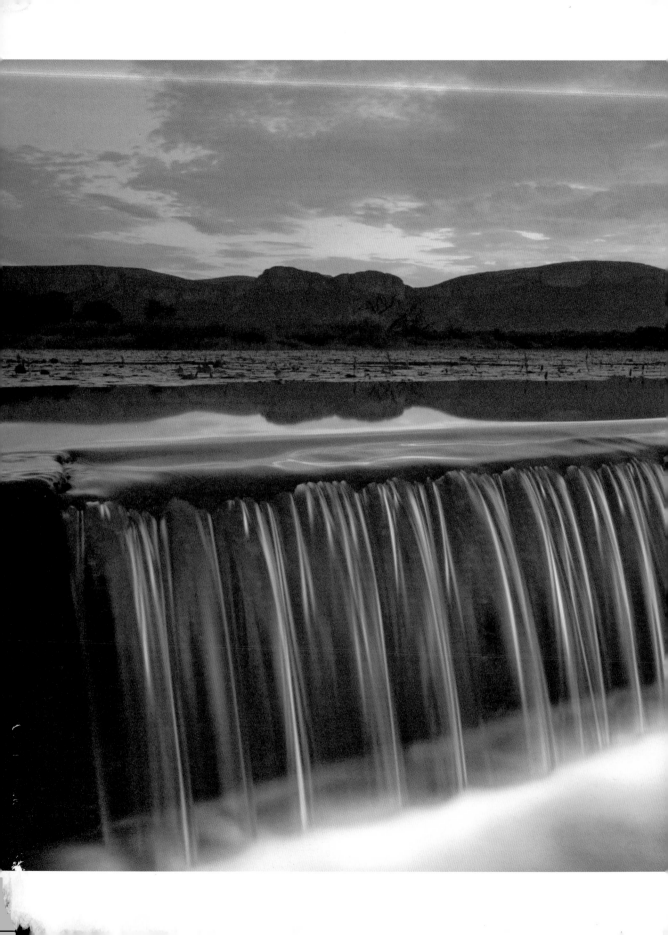

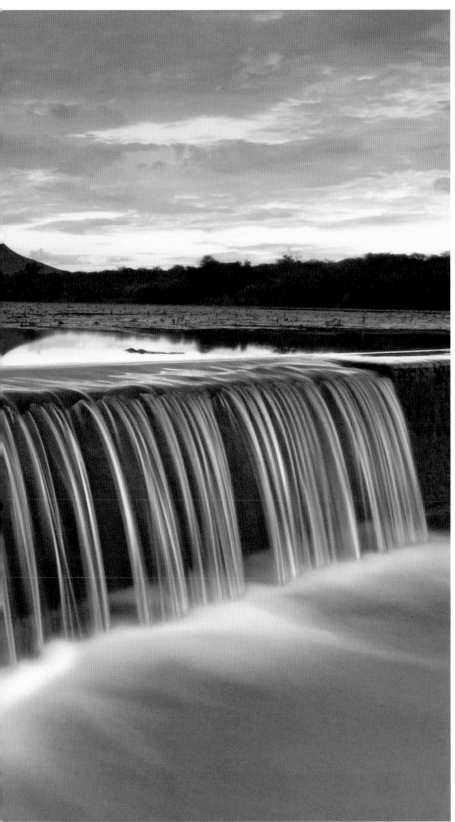

Left *To blur the motion of the water, I exposed this image for over two seconds. Long exposures can generate a lot of colour noise. This is apparent on the far left of the image, but it is relatively easy to remove during the later stages of the workflow.*

Therefore there is no reason to fiddle or get stressed with the white balance at all, just set it to 'auto' or 'daylight' and forget about it. I use 'daylight' so that I work from a consistent point when correcting my images, if it is wrong then a couple of clicks are all that's needed, that's the beauty of RAW!

Long-exposure noise suppression

Long exposures in poor light conditions are a recipe for generating sensor noise. This manifests itself as coloured dots, which vary in intensity according to the conditions and length of exposure. Some digital cameras offer built-in noise reduction or noise suppression, which reduces this effect on the RAW file. This is great in principle, but its actions cannot be reversed and noise suppression generally causes an image to have less detail. This is all controlled within the camera, and the general feeling amongst most professionals is that the photographer should control the amount of noise suppression. Therefore this should be done either in the RAW conversion software or at the post-processing stage, using specialist applications such as Noiseware or Noise Ninja. In other words, it is best to leave any internal camera noise suppression switched off.

Shooting parameters

Most digital cameras allow shooting parameters such as exposure, contrast and saturation to be tweaked internally by the camera. This is primarily intended to allow photographers who shoot JPEG to get a more usable image straight from the camera. For RAW shooters, these values should be left at their default settings, which leaves all of these settings to standard (default) and also which leaves sharpening at 0. The name for these modes vary from camera to camera, for example, 'Faithful', 'Neutral' or something similar.

Picture styles Some cameras now have pre-supplied picture styles for their files, for example, you can choose to shoot 'landscape', 'warm tone' or many other such combinations. This may seem like a good idea, and for JPEG files it is, but for RAW files it again depends on the software recognizing the picture style parameter and displaying the RAW file accordingly;

some software does this but not all. DNG supports some of these parameters, but not all of them and it varies between manufacturers; if in doubt switch it off as these effects can be recreated later on.

Naming standard

Digital cameras generally name their images with the first four characters being fixed and the next four being a sequence from 0000 to 9999. When the number gets beyond 9999, the camera resets it to 0000, which means it will be duplicating a file number to one that already exists. Therefore you should delay this happening as long as possible by setting the digital camera to the option that does not reset the numbering each time a new card is inserted; this is called 'continuous' on some cameras. Doing this will give you plenty of time to edit and rename the RAW files that you keep, to a new unique numbering system (see page 65).

Colour

Some digital cameras give you the choice of whether to shoot in colour, black & white or some other monochrome setting. If you shoot JPEG, then it is vital that you choose the correct setting as it is permanent, but for a RAW file this is just a parameter; so even though you choose black & white, the RAW file will still retain all of the colour information. In fact it is unlikely that even if you choose to shoot black & white that the RAW software will be able to recognize the parameter so it will just display it in colour only. Therefore it makes sense to just stick to colour and to change it to monochrome on computer.

Colour space

Another confusing option for newcomers to digital photography and one that is largely irrelevant for RAW. The safe option for most photographers is to choose sRGB as this will be the colour space that you want to use for printing, emailing and putting in the web. Adobe 1998 (usually the only other option) shoots with slightly flatter colours, and is generally used by professionals who are shooting for publications and agency submission. At the end of the day, it doesn't matter since you can change it later anyway.

Exposure explained

This section we will show you how to use your LCD histogram to get the best quality RAW image, and to minimize any time spent on the workstation. We will also answer such common questions as: 'Why do my digital images look flatter than I remember seeing with the naked eye?'

A change of philosophy

When you start shooting with a digital camera, it is important to stop thinking like a film photographer, because those constraints have been removed from you. Perhaps the biggest change should be in the way that you think about the correct exposure of your images. As a film photographer, exposure was always an educated guess, it was still open to an element of chance whether the exposure was good or not. While you could use the various metering modes that were available to you, as well as tools such as bracketing and so on, you could never be entirely sure that you had got it right until the envelope with your slides in dropped onto your doormat. If you had got it wrong, and it has happened to all of us, professional and amateur alike, it was too late.

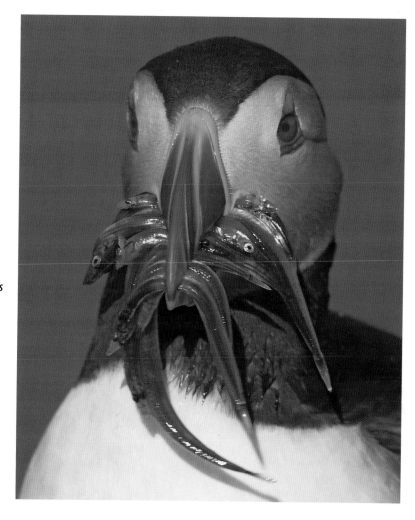

Right *A difficult exposure such as this has the extremes of pure black to pure white. To get this image I had to shoot just after dawn in soft light so that the whites would not burn out and would be easier to manage. A spot meter reading was taken from the beak (which is midtone) and then had a third-stop of negative exposure compensation applied to ensure no highlights burnt out.*

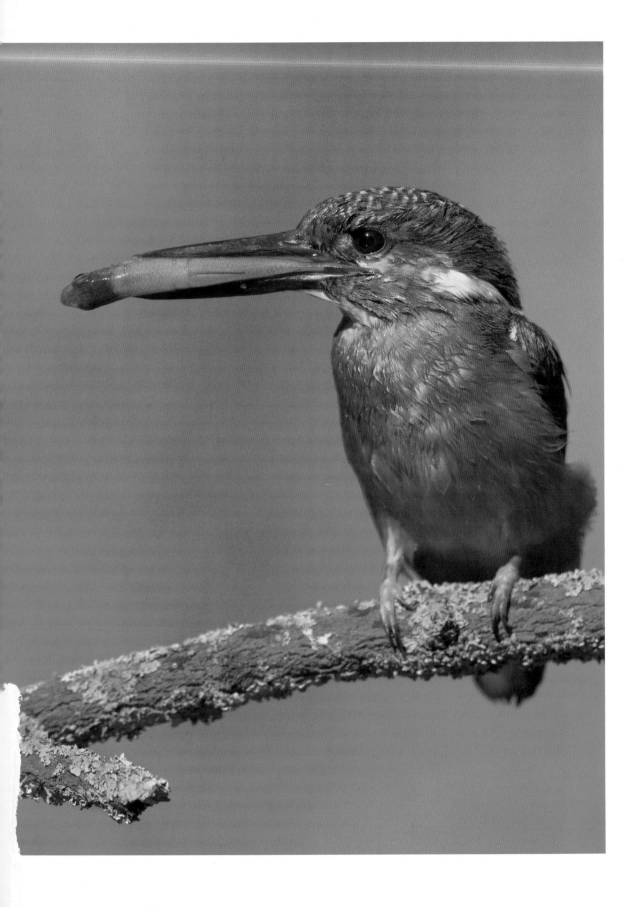

It is this exposure uncertainty that the digital camera has buried for good. The key to this is the LCD histogram that is displayed on the back of a digital camera; this will tell you in an instant whether the light meter is being fooled and the image is vastly under- or overexposed. Most photographers, however, use the LCD for inspecting a picture that has just been taken; this is called 'chimping' in the trade and is a terrible habit to get into. Unless you have alien eyes it is virtually impossible to see focus or any detail on the screen and you certainly cannot judge colour or exposure accurately! The LCD histogram though, will tell you everything that you need to know at a glance and will allow you to get your images exposed correctly 'in-camera'. This is a vital consideration as getting it right at the time saves hours in front of your workstation, which is certainly not my cup of tea.

Dynamic range

Before launching into too much detail about how the digital camera can help you get consistently good exposures, you need to understand how the sensor within your camera sees and records the world.

The sensor records image detail from pure black (the darkest shadows) to pure white (the brightest highlights). The latitude that a sensor can record

Q What is the dynamic range?

A The difference between the darkest shadow and the brightest highlight that a sensor can record detail in.

Left *A nice exposure and a balanced image between foreground and background gives a good range of tones that makes the most of a sensor's dynamic range.*

successfully is in the order of about five and a half stops of light, in other words, the difference between the darkest shadow and the brightest highlight must be within this range to be recorded effectively. This is called the dynamic range. Anything outside this is either recorded as pure black with no detail or horribly burnt out white. This is one reason why a RAW image is not always as you remembered it at shoot time, as our human eyes have a dynamic range that is roughly double that of the best digital camera available today.

Reading the histogram

All digital cameras display a histogram on the LCD, which is a doddle to read, as it simply displays the dynamic range that the sensor can resolve (as already discussed). The pure black pixels are the extreme left of the graph and the pure white pixels are at the extreme right. Everything in between is the range of tones and colours that we can see in our image and the area right in the centre is commonly referred to as midtone or 18% grey. If there is a large upwards peak, then this indicates a concentration of this particular tone in an image, which is not a bad thing, provided that it does not occur at the extremes of the range. If you get peaks at either end of the scale, then the image has significant tones that are not being recorded by the sensor as they are outside of the dynamic range; they will just become featureless black or white. In fact sensors are particularly good at burning out any highlights in an image, whether shocking white make-up, white fur or bright highlights of the sky through some trees, these are often outside of the dynamic range of the sensor. And it will burn out, horribly, which is one reason why it is rare to get the same detail in the setting sun that you did with slide film. Therefore it is imperative not to have a peak on the far right of the histogram and this should be avoided at all costs. Read on to see how this can be achieved.

Shooting in the field

OK, so we've covered how sensors deal with extremes of black and white, and how the LCD histogram is an invaluable tool. You might ask, did I really need to know all of that? The simple answer is yes, as this can now be applied to the real-world problem of how to get a good, usable image from the camera. The problem is that although you would think that the best histogram to get is one with the peaks near the centre and with a reasonable spread, this is rarely possible in the real world. What you usually get is a collection of various mountain-style peaks or flat rolling hills, which rarely, if ever, look anything like the perfect bell-shaped curve printed in so many manuals and books.

Evaluating the scene

While the histogram is a great tool, it does have its limitations. Essentially it shows you the tones that the camera has captured. Do not confuse this with the tones of the scene itself. The histogram still relies on the camera meter: if your meter is being fooled by a very bright area (perhaps because you are spot metering on it) then the resulting histogram shows underexposure, peaking to the left of where the peak should accurately be. By the same token a dark subject may also cause severe overexposure, with peaks to the right of where they should be. Neither of these are problems with the histogram, as it is simply showing you what has been recorded.

Both of these situations can be corrected with a little exposure compensation, but before running straight into this (and potentially ruining the image), you first need to sit back and look at the picture and decide what you want from it. Photography is an art form and a way of expressing yourself. Sometimes this means that you do not want what might normally be considered a 'perfect' exposure, perhaps you want a dark and moody scene or a vibrant and bright one. Maybe the scene in front of you only comprises very dark colours, therefore the histogram will peak to the left anyway. Compensating to achieve a more normal-looking histogram will ruin the effect of the shot. Therefore, when looking at the histogram, it is essential to remember how you are metering, what you are metering from and how you want the final image to appear.

Left *An example of how the light meter can be fooled by a white subject; in this case the resulting histogram was biased to the left because it is underexposed slightly. Note that the underexposure would have been greater had the image not been taken in the soft light just after dawn.*

Right *An example of the meter being fooled by a dark subject; the centre-weighted metering pattern covers mainly the face so the resultant shot is overexposed with a right-hand bias to the histogram.*

Left *In most relatively straightforward lighting conditions the program exposure mode will provide reasonable results, however, it doesn't give you as much control as other, more sophisticated modes.*

Exposure techniques

There are many ways of getting the exposure that you want, and a few of the most commonly used are listed below, along with usage tips and their pros and cons:

Using program exposure

Some readers of this book will simply put their digital camera on program mode (P, green spot or something similar) and then point and shoot. In good light and with subjects with a wide range of colours, the histogram will be fine and the resultant image will make a nice print with a few tweaks here and there, although you may have sacrificed a lot of creative control over certain variables.

Technique Set the digital camera to program mode and set the aperture and shutter speed combination to give you the result that you want. Set the metering

PRO Tip

Unless you are dealing with a mix of extreme colours, simply set your metering system to the widest possible mode, in other words the one that takes account of the scene as a whole. This is often called 'Evaluative' or 'Matrix' metering and will give consistent results in the majority of good conditions.

mode to multi-segment metering (usually labelled 'Evaluative' or 'Matrix'), take the shot and display the histogram. If it is too far to the right or left, then use the exposure compensation button to apply some correction.

Advantages Suitable for entry-level photographers, because it allows you to concentrate on composition and focus.

Disadvantages Too easy to burn out highlights, the camera is in control of exposure, therefore the final image is not always what you want to see. Most readers of this book probably want to know a bit more about how to get the best out of their RAW files than this method can provide.

Shoot left – underexposing for highlights

Many areas of photography, such as sports, reportage and wildlife, do not lend themselves to a great deal of preparation time for each shot and have limited opportunities to make corrections and reshoot. Once the initial metering and exposure compensation has been applied, there is no time for checking the histogram and making any corrections. Professionals soon realized two very important facts about digital exposure: firstly, the only thing that will ruin an image totally is highlight burn out, almost everything else can be easily corrected by RAW software; secondly, it is very unlikely that a digital camera will underexpose an

Whichever method you decide to use, it pays to try to get the basic exposure right before you shoot. Whenever I get a chance, I take a test shot and check the histogram, compensating the exposure whenever necessary to get a base exposure. Then, if the light is constant and I don't think that it will change much, I put my aperture and shutter speed values in using manual exposure mode. I know that the exposure that results will be close to the base exposure, close enough not to matter anyway, and I can happily forget about the exposure and concentrate on getting the shot in focus.

The bottom line

Right *A great example of using the 'shoot left' technique to get a faster shutter speed. To stop the kingfisher in full flight needed a shutter speed of around 1/8,000sec, but the available light (shooting at ISO 400) only allowed around 1/2,000sec. So two stops of negative exposure compensation was applied to give the required shutter speed, but of course a slightly dark image.*

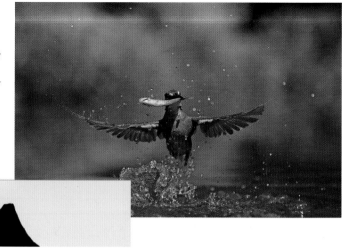

Right *This is the histogram given by the shot, the fact that it is so far to the left will mean some noise will be apparent in the shadows after brightening it.*

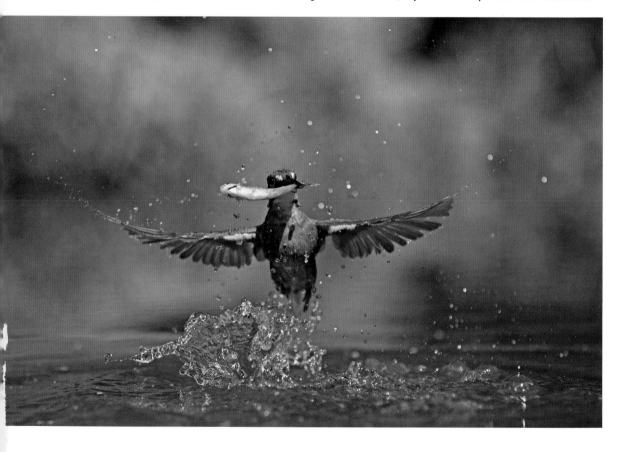

Left and below *A few clicks in the RAW software and the kingfisher now looks completely different. Exposure and contrast sliders were used to bring up the brightness levels and specialized noise-reduction software was also employed. The result, a fantastic image that has sold many times. To the left is the histogram after correction, as you can see the peaks are more centralized.*

image so much that it cannot be corrected. I have had seriously underexposed images, by as much as two stops, recovered enough to be commercially usable. Therefore the only thing to really worry about is burning out the highlights, and the obvious, and virtually foolproof, way to do this is by slightly underexposing the image when you are shooting. This usually gives a histogram with its peaks to the left, which can be corrected later.

Technique Set negative exposure compensation of between a third and half of a stop and then shoot! That is it, nothing more is required and you can shoot, safe in the knowledge that you will not be blowing out any highlights in the vast majority of the shots you take.

Advantages This technique is a very simple one to follow, and avoids highlight burn out in almost all cases. It also allows you to use a slightly faster shutter speed or narrower aperture due to the inherent underexposure; this can make the difference, particularly in low-light situations, between a sharp image and a blurry one. In dark conditions these advantages far outweigh the disadvantages. Remember, it is getting the shot that counts the most.

Disadvantages If you have already applied some negative exposure compensation to the exposure, perhaps to correct for a dark subject, then you will get

This method works well if you need extra shutter speed, for example, to freeze some fast action that you are trying to photograph. I have shot as much as two stops underexposed when I need extra shutter speed, as this is the difference between shooting at 1/125sec and 1/500sec. Sure, I get some noise, but for these kind of pictures I feel it is an acceptable amount. It is better to get a shot with noise that is sharp, than a blurry image that is perfectly exposed.

◎ The bottom line

a very dark image with histogram peaks to the far left. Noise can also be an issue, as most of the noise in an image resides in the dark, shadowy areas (see the next method) and brightening the image will make that noise more visible. (Chapter 4 gives some guidance on the processing needed, in order to get the maximum quality when brightening such images.) Also, this method does not take advantage of the full dynamic range of the sensor, so you are not recording all of the areas of brightness available to you.

Shoot right – overexposing for detail

This method could not be farther removed from the first two, and at first glance goes against every piece of advice given so far in this chapter. The key to using this method is to overexpose the image so that it peaks to the right of centre, but away from the right-hand edge. Yes, that is right we are going to deliberately overexpose the image! This is a new technique that has been 'discovered' by the more technically minded photographers who understand sensor theory; it is gaining popularity and although it seems odd, it certainly works if you apply the logic carefully.

This technique requires a big leap of faith, and at first it may seem counter-intuative; however, bear with me, and if you don't believe it, then check out some of the websites listed on page 139.

Sensor technology is such that the brightest half of tones that can be captured is contained in only a fifth of the whole dynamic range. This means that the remaining four fifths of the dynamic range are only recording the other half of the image data; in fact they record progressively fewer tones the darker they get. In plain English if we assume that the image has roughly 4,000 tones, then 2,000 of them are represented by the right-hand fifth of the histogram, in other words the brightest part of the image. The other 2,000 are spread progressively more thinly across the remaining four fifths of the histogram. So if the histogram contains no values in the upper fifth, as it often will when using the 'shoot left' technique, or even when you have a central curve, you have in effect wasted half of the available tones. Whether this lack of tones is visible or not is another question, but the technical arguments

Below and left *To get the maximum quality from the shot I decided to use the 'shoot right' technique; this took a few test exposures but in the end I managed to get this shot with the histogram to the right, but no highlight burnout. After a few clicks and some adjustments in curves this is the result: a beautiful image of a glacier in South Georgia.*

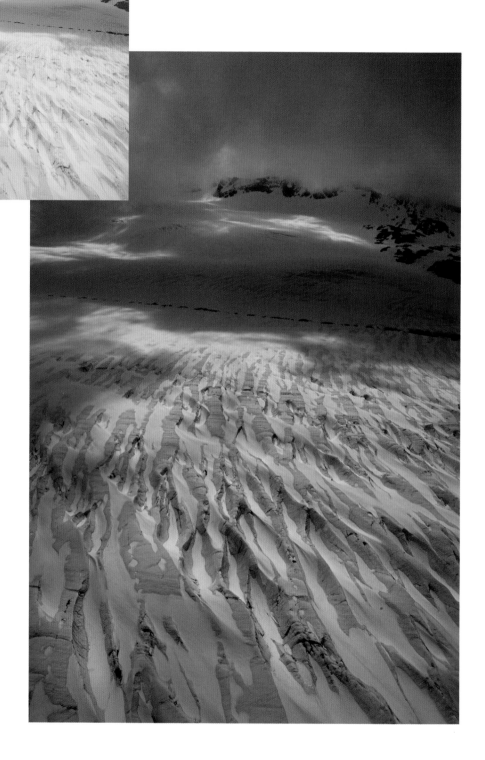

have merit, and additional tones offer you more flexibility when it comes to making colour corrections. Unfortunately, using this technique for exposure is a lot more involved than the previous methods and is not suited to quick shooting. It is easy enough to dial in some level of overexposure, but the problem is fine-tuning the exposure to ensure that the main peaks are in the final fifth of the histogram without any being against the extreme right axis – if they are, then the highlights will be blown out and without detail.

Technique Requires constant modification of the exposure-compensation function to balance the exposure at the right-hand side of the histogram.

Advantages Much less noise in the shadows; using the sensor to peak efficiency so maximizing its dynamic range and therefore image quality; creating more flexibility for colour corrections later on.

Disadvantages Slow to use when shooting in the field as several adjustments to exposure compensation may be necessary. There is a fine line between getting it right and burning out the highlights. You also need to be aware of the effect on shutter speed and aperture that overexposing the image has, one of these must change and it is usually the shutter speed as most photographers shoot in aperture-priority mode. This means that your shutter speed, that was happily 1/500sec will need to drop, perhaps by as much as two stops to 1/125sec, which can have disastrous results. Therefore it might pay to switch to manual mode, dial in the base exposure and then open up the aperture (unless of course you need the depth of field). Recovery of these images is covered in chapter 4.

This method is great if you want to maximize the image quality that you can get from your camera; but in many situations what it costs you in shutter speed and time spent perfecting the exposure makes it impractical.

◎ **The bottom line**

Conclusion

Clearly all methods have their pros and cons, but, unless you are incredibly picky about your images and really want the optimum in quality, the 'shoot left' method is by far the easiest. To be honest if all you are shooting for is to make a nice A4 print (which applies to most photographers out there) then just setting your digital camera to a third of a stop negative compensation will be good enough in the majority of situations. However, for anyone who really wants the absolute best from their RAW file, or who is working with a studio setup that allows them the time to fiddle without worrying about moving subjects or changing light, then the 'shoot right' technique makes sense.

One additional point about the 'shoot right' method is that it shows the merit of not assuming that an overexposed image is only destined for the recycle bin; provided there is no large-scale burnout of the highlights, then the image can be recovered easily and may in fact be of a better quality than others in the sequence that are initially perceived as being correctly exposed.

My previous technical book, *Digital SLR Masterclass*, included hints and tips on using your digital camera in the field. The response from readers showed this to be a lot of help to many people; therefore I have updated and revised the information here. But why bother with field techniques in a book on RAW? Well, the reason is that they all have an impact on quality, and getting the best possible quality from your file is what RAW photography is all about. So here are my tips; they are not intended to be exhaustive, but take it from someone who uses a digital camera in his everyday life, they will help improve your picture quality.

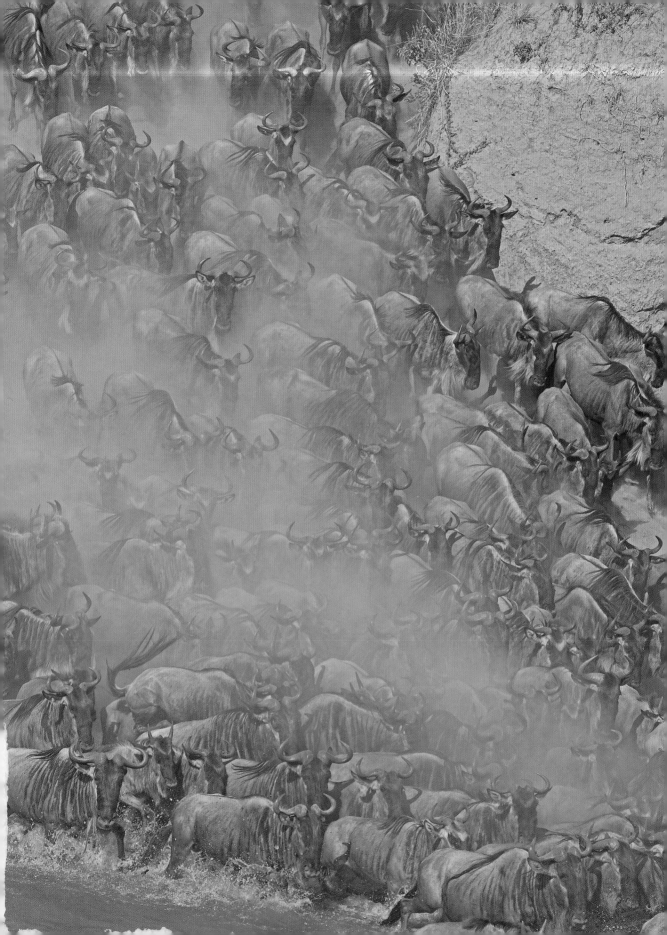

Field techniques

Keeping the sensor clean

Sensors are charged devices and so attract dust. Most of this is small enough to be invisible at magnifications about 100% and can be effectively ignored. The real problem comes with larger dust spots (or even water and grease spots) that are visible at even the smallest magnification and can detract from the image. Of course, dust spots can be removed from the RAW image using software tools, this is a simple job, but it can take a lot of time especially if you have a filthy sensor. It can also be a real chore knowing that you have to clean every image before sending it out, especially if you are a professional photographer sending out proofs. Some manufacturers have started to address this issue by including the following measures in their cameras:

Vibrating sensor This is a built-in sensor-cleaning function, which, in theory, vibrates the sensor at supersonic speed to shake the dust off onto a sticky pad.

Blank reference image Some cameras allow you to take a blank image of a neutral subject (such as an out-of-focus background) which is then used as a reference by the RAW software to clean the other images from the shoot. This is a very clever method of preventing dust and works provided that you remember to take this special image (accessed via the menus) just before you shoot. Canon calls it dust delete data, Nikon offers support for it too and many others will doubtless follow.

As always, prevention is better than cure, so the best course of action is to avoid exposing your sensor to dust. This means keeping the same lens on the camera body as much as possible, to reduce any new dust entering the shutter chamber; if you have to change lenses, then do so quickly, away from wind, rain and dust, and always get the new lens onto the camera before worrying about putting caps on the old one. I have learnt this from experience as I once changed a lens in the rain, and there afterwards was a huge water spot right in the middle of the sensor. And I was on a remote island for two weeks with no communication. At times like this you have to clean the sensor yourself.

Cleaning a dirty sensor

Prevention is one thing, but in real life sensors will get dirty. I change lenses while hanging out of helicopters, racing along in a safari vehicle and occasionally in the rain, so eventually I, like anyone else, will suffer from sensor dust. If possible, I always send the sensor away to get cleaned by my old friend Safdar, at my local Canon Service Centre, as it is better to get it cleaned thoroughly by an expert; but of course this is not always possible and I will often have to remove a dust spot myself in the field.

The first thing to know is that when you expose the sensor (by using the sensor cleaning options from your LCD menu) you are not actually exposing it to the outside world. You are only exposing the low-pass filter that sits on top of the sensor, so anything you do is not to the sensor itself. But this area is surrounded by complex electronics and it is very sensitive to pressure, so you have to treat it very carefully. Before saying how to clean the sensor, here is a list of how not to:

- Never use a standard camera-cleaning cloth as you will introduce more dust and fibres than were there in the first place.

- Never use any kind of lens-cleaning fluid.

Left It doesn't get more dusty than the annual wildebeest migration in Kenya, which is a nightmare for DSLRs. I avoided exposing the sensor at all costs while outside, reasoning that I can remove a few dust spots on the sensor later on with software.

● Never, absolutely never, use a can of compressed air. These can contain water droplets and you will be spraying your sensor with a fine mist of water; it will do wonders for your soft-focus effects, but achieve little else apart from an expensive repair bill.

● Never use a blower brush with the brush fitted – the bristles are too rough.

OK, so that is the list of what not to do, but how should you do it? There are several different tools and techniques that you can use:

Large blower bulb I used to use an oversized blower, but without the brush. These are specially designed for DSLR sensors and deliver a fine blast of air at the sensor, which in theory should remove all dust. Mine usually did, but sometimes it blew in more dust than was there in the first place!

Electrostatic cleaner These small devices have a fine brush on one end that is spun before cleaning to create an electrostatic charge. This attracts the dust from the sensor (and any floating around it too) and provides a high-quality clean that will remove almost all dust. I use the Invisible Dust Arctic Butterfly, which has a brush made of hairs ten times finer than human hair and is powered by a single AAA battery. To use one, simply insert the correct brush size (for a full-frame or cropped sensor), expose the sensor and hold the camera upside down, while gently wiping the sensor with the brush just once. It pays to keep a close eye on the sensor while you are doing this, and it is essential to keep the brush from touching any parts of the camera chamber other than the sensor. These units work really well in the field and are the least invasive and, in my opinion, the most effective of all cleaning methods.

Swabs Many digital photographers use swabs to clean their sensors; these are designed specifically for the size of the sensor and require a small amount of cleaning fluid to be applied to the swab before use. It has always been my opinion that putting fluid onto the sensor, no matter how safe, should be reserved for the situation when you absolutely have no choice. I always clean the sensor these days with the electrostatic cleaner first and only use the swabs to remove any water or grease spots that need some extra help.

Just remember that the sensor is the most vulnerable part of the camera; so, whenever you clean it, do so very carefully indeed.

Managing the buffer

In case you don't know already, all digital cameras have a temporary buffer that stores your files before writing them to the memory card. This buffer varies in size between different models of camera, some have enough space for just a handful of RAW files while others offer far more. In any case, at some point in your photography, you will come to the point when there is no more space in the buffer; at this point the camera stops you taking any more shots, or slows the number of frames per second dramatically, and this is called buffer lockout.

Undoubtedly buffer lockout is the bane of my digital life. I use a digital camera that has a buffer that can accommodate nine shots in a row, which is no problem for most subjects, but presents a real problem when the action is fast and furious. Often I am taking pictures faster than the buffer can clear and this will always result in frustration, desperately pushing the shutter-release button hoping that the camera will free itself to take a shot.

The only way of managing this is to be prudent when you shoot, by only shooting when the picture is good and not just blasting away. I have met many such 'blasters' on my courses, who rely on a high burst rate to get shots, and most take pictures that lack good composition, focus or both. Inspirational photographers such as Galen Rowell or Ansel Adams took relatively few pictures per day, but what they did take was astounding as they waited for the picture that they wanted. We can all learn in this respect from the great photographers of our time.

Right *Managing the buffer is of crucial importance so that you don't find yourself short of frames when you are faced with fast-moving subjects such as this grizzly bear.*

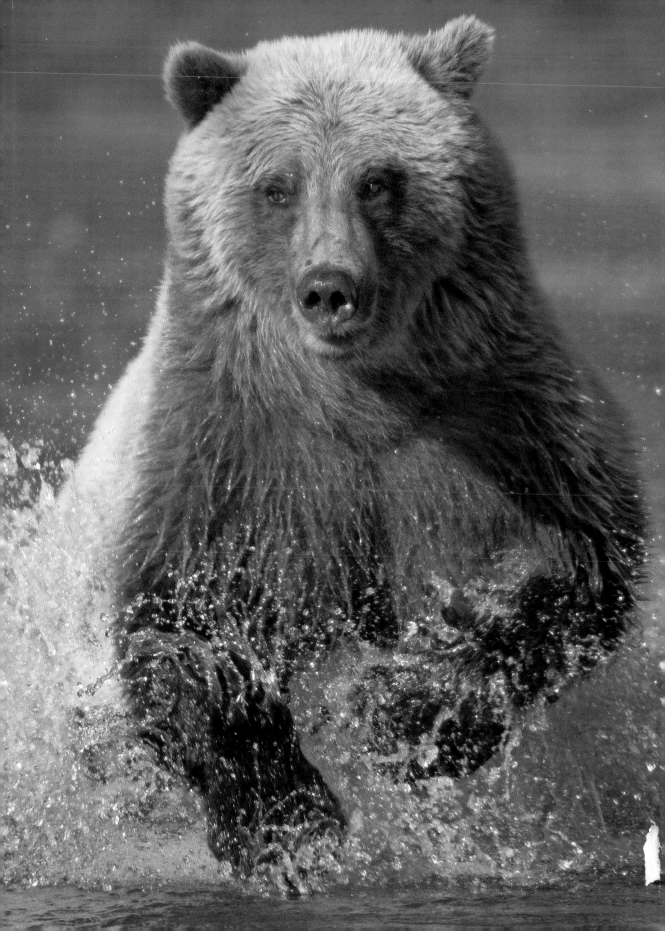

Q **What size memory cards do you use?**

A My maximum is 4GB, even though larger cards are now freely available. I always take the view that the biggest single point of failure in the whole system is the card, as it is easy to be complacent. With such a large-capacity card, it may take months for some photographers to fill it up and therefore files will be left on the card between shoots. This is a recipe for disaster as they can be easily deleted (thinking that you had downloaded them already) or the card could develop a problem or even be lost.

Either way it pays to get your files off the card as soon as possible and into an environment where you are able to back them up safely.

Above *The JOBO GIGA Vu PRO evolution is a sophisticated portable downloader that I use to store my images in the field. It is available in a range of capacities and has a touch screen through which you can access various functions.*

Backing up in the field

When it comes to backing up in the field, I use a portable downloader, which is really a glorified hard disk with a slot for various card types. They come in various forms, some are simple with just a copy switch, while the most complex have full-colour screens and a sophisticated user interface. Whatever their features, their basic function is always the same, to allow you to back up your files from the card to a safe place so that you can reformat the card and use it again. When back home such units can be connected to your workstation and your RAW files copied across; you will see in the next chapter how I actually do a lot of editing directly from the downloaders, as they are effectively external hard disks.

When choosing a downloader, you should look at the download speed of the card to the unit, as some can take 20 minutes to download a 4GB card. Also try to get one that verifies the download to ensure that it has worked correctly; there is nothing worse than reformatting the card and then finding that the download failed halfway through. The unit I use, a

Jobo GigaVu Pro Evolution, has all these features and a back-up too, so that I can create an extra back-up to an external hard drive. This makes good sense when I am away from home as it takes just a few minutes to do, and gives me peace of mind at the expense of just a few extra cables.

Editing in the field

Whether I edit in the field or not depends on whether I have access to power on a regular basis. If I do then I will often use my downloader to edit images, as it displays them in full colour on a good-quality screen and it allows me to zoom in as well. Of course, this really eats up the battery, so I only do this if I have it connected to mains power. I never edit in-camera using the LCD screen and would recommend that you don't either. The main reason is that the LCD screen is useless for evaluating images, but a good secondary one is that using the LCD screen really shortens the battery life. Any action that runs the risk of the battery being dead at a time when you need to take a shot is one that needs to be avoided. Remember the camera is best used for taking pictures, nothing else.

Saving battery power

Anything to do with the LCD screen uses valuable power. So turn off all histogram functions, since you do not really need to know the histogram after every shot. This comes from the confidence of having a good exposure technique – provided you follow the guidelines that I have already set out in the exposure section, then there is no need to keep checking the histogram as long as the light is constant. This will do wonders for your battery life.

Q **Why not use a laptop?**

A I try not to as laptops are best for sending emails, playing music and killing space aliens! A laptop is a cumbersome, fragile, power-hungry piece of kit to have in the field and it also distracts from the job at hand – taking pictures. Add to that the snail's pace of trying to use the PCMCIA adaptor for transferring images from a card and you have a very impractical device. Of course I know many photographers who take a laptop along as a device for creating backups to CD or DVD, but I have never done this as it takes up too much time; I prefer to have the automation of a downloader as mentioned above.

Following page *In remote locations it is even more important to manage your images effectively in the field. This mountain gorilla (Gorilla beringei beringei) is a blackback male (not dominant) shot in the Virunga Mountains, Rwanda.*

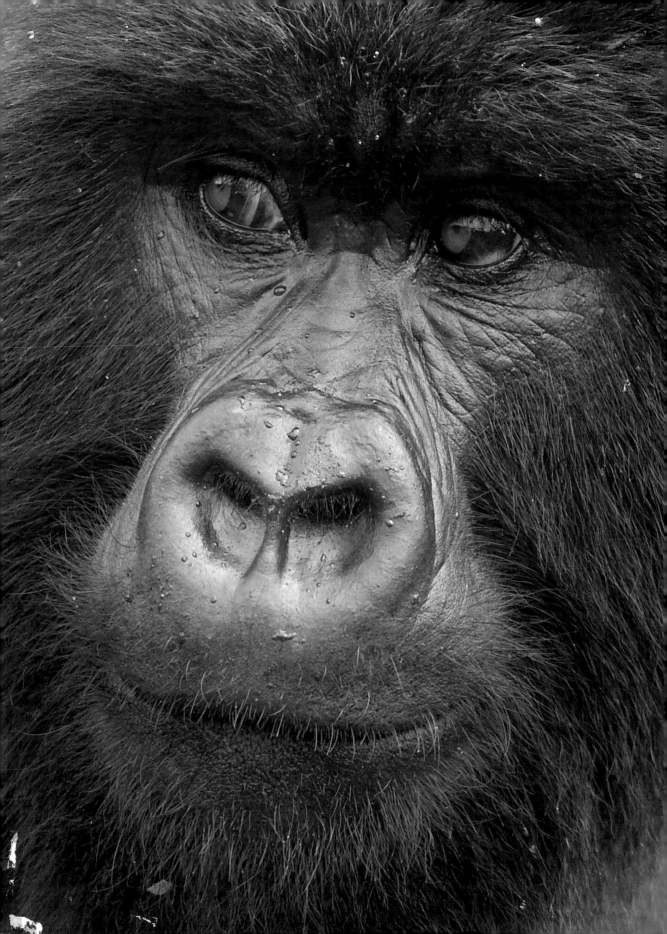

Q What are your 10 top tips for anyone using a digital camera?

050 | 051
IN THE FIELD

A This is a difficult one, but in terms of getting the best results with the least hassle try these:

1 Only clean the sensor when you absolutely have to, a little bit of dust can easily be cleaned away using software later on.

2 If you have to clean the sensor, then buy an electrostatic cleaner.

3 Clean your lenses thoroughly and keep them clean. Pay particular attention to the rear lens element, as this is where new dust and particles can be introduced into the camera chamber and onto the sensor. Keep the back lens caps on at all times.

4 Avoid 'chimping' at all costs. This is the practice of looking at the LCD screen after each shot to see if you have got it in the bag. You cannot tell from the LCD whether you have or not, you are wasting valuable battery power and worst of all you are missing shots while you are doing it!

5 Get at least two high-capacity memory cards. This will ensure that you will always have enough space to shoot for almost any eventuality. If you have a dual-slot camera that takes both SD and CF cards, then fill both slots.

6 Always take a test shot at the aperture and shutter speed settings that you want and evaluate the histogram as has been previously described. If you need to tweak the exposure, then do so until you get the right combination and are happy with the histogram. Then, provided you are in constant light conditions, put those values in via the manual exposure mode, forget about them and concentrate on the composition and getting the subject in focus. The less that you have to worry about the better.

7 If you take a great shot then use the 'protect' function on your camera (usually only on DSLRs) to ensure that it cannot be accidentally deleted from the card.

8 Always format your storage cards before you use them, to remove any old images. In the next chapter you will see how you should always copy the RAW files to your workstation as opposed to moving them, therefore any card will probably have old images on. I have lost count of the number of times I have loaded an apparently fresh card, in the heat of the moment forgot to format it, and then found out after shooting a few images that the card already has 400 images on it and is full. If the new pictures are rubbish, then a quick format saves the day, but if you want to keep them, then you will need to toil through the card deleting the old ones one at a time. Prevention is always better, format it first!

9 Don't blast away at full speed, pick the shots you want and take them. This will not only get the shot that you want, but will also ensure that buffer lockout does not spoil your chances of getting a real winner.

10 Finally, try to spend your time out in the field taking pictures rather than on the computer worrying about technical issues that you can do nothing about.

Editing essentials

With the lessons learnt from the previous chapter, you will have now shot a few RAW files, or perhaps have thousands of them on a portable downloader after a big trip. Starting with how to get your RAW files onto the workstation, this chapter then moves onto various techniques for editing your RAW files. This will help you cut down a large number of RAWs from a shoot to just the best of the best, your finest RAWs of which you are most proud. Along the way we will cover the issues of back-up and renaming too, both vital considerations in the RAW workflow.

Downloading

I remember the first time I photographed the awesome sight of a cheetah running at full speed. My EOS 1V HS 35mm SLR was loaded with Provia 100F, pushed to 200, and I managed to shoot all 36 frames in little over five seconds. Two years ago, repeating the same exercise for a cheetah book I'd been commissioned to write, I shot over 150 RAW files with the blazingly fast EOS 1D. Shooting the fastest animal on land is one thing – anyone would be excused for racing through memory cards – but what about static subjects? As portrait and wedding photographers know only too well, even an almost static subject will move slightly over the course of a few frames. Therefore we all take a lot of images to cover for this eventuality.

Below *Shooting long bursts in order to capture fast-moving subjects creates the problem of having to manage your file downloads effectively in the field.*

There is no doubt that the digital camera has allowed us to shoot in a much less constrained manner, and as a result we all shoot far more images now than we ever did with film. In fact, it can be said that we all shoot far too many images. The challenge for anyone is to find the real gems amongst these thousands of images, and for this you need an efficient editing workflow that saves time. One other good reason for having a very aggressive workflow is one of workstation disk space; with RAW files growing in size as cameras develop, it will not take long for a hard disk to start filling up and the performance of the machine to falter.

It might seem strange, but you have to make the decision whether it is preferable to download all the RAWs onto the workstation and edit them, or to edit them on the media where they are stored and then only download the good ones onto the workstation. Here are your options:

Download and edit
If you are going to download your unedited RAW files to the workstation, you should be aware just how much storage even a hundred RAWs can take – roughly 1GB with a 10-megapixel camera. If you have about this number or less, then download them as they can then be edited down within a matter of minutes to a much smaller number.

Edit then download
If you are using a downloader, then this means that you have probably taken a lot of images. In turn this means that if you load them onto the computer, then you had better edit them down pretty quickly, otherwise they will take up a lot of hard disk space. A better option is to use a downloader as a portable hard drive and edit directly from it; since they are mostly USB 2.0 devices the read and write speed should not be an issue. When you have finally edited down the number of RAWs to a more manageable amount, then you can download the good ones onto your workstation.

Download Software

There are many options for getting the RAWs onto your workstation, the simple way is to copy them using the operating systems. This a pretty cumbersome and labour-intensive method, a much more fluid one is offered by an increasing number of RAW software applications. Some use a simple drag-and-drop interface whereas others have full-blown applications with a multitude of features that allow you to catalogue your images, add keywords and do all kinds of fancy stuff during the download.

Above *A download dialogue box that shows the settings for downloading from a card reader to a folder on the computer; note that the 'move' option is unchecked.*

Right *A more sophisticated import dialogue box which can assign keywords and captions as well as performing other tasks such as converting to DNG format.*

No matter what method you choose for downloading there is one golden rule – copy the files, don't move them! There is a simple reason for this, things can and do go wrong with downloads, software, hard disks and so on; if you choose to move the files, then you have no back-up if anything goes wrong. If you choose copy them, however, then you will always have a back-up of your RAW files to go back to – until you press the format button of course! This is one reason why I suggested in the previous chapter that you choose a downloader with a back-up option.

Q When do you edit your files?

A I always try to edit before I load the files onto the workstation as I want to keep the workstation as free from clutter as possible. As I am a prolific shooter, I would quickly build up a huge backlog and fill up the available space on the workstation, therefore I always edit away from the hard disk. Since I always create a back-up drive from my main Jobo GigaVu PRO Evolution downloader this gives me a perfect medium on which to edit as the drive is fast and very reliable.

Preview

_e9m2382

_e9m7525

_e9m7526

_e9m7527

Check All Uncheck All

Import Cancel

Downloading to DNG

Some RAW software can automatically convert your RAW files into DNG at the point of download. So no matter whether you are downloading just a few images or a whole downloader worth, your DNG files will be ready to start the next stage of the workflow.

Editing basics

So now you are set; your RAW files are either on the workstation, or you have an external drive warmed up and ready to go. There is no doubt that editing is a very boring process and one which we would all rather not do. To alleviate the inevitable boredom, and to prevent good images being mistakenly deleted through complacency, it is best to split up the editing into several different phases. The idea is that each phase stands alone and can be picked up at any time, something that is vital given the demands of the rest of your life, I'm sure. If you cannot complete the editing of your RAWs in one session, then just use one of the many tagging features (see page 64), which your chosen RAW

software will have as a digital bookmark. Don't edit when you are in a bad mood either, or on the day that you shot the images as you will be too close to them – a good editor is an objective one, you need to stand back and look at your pictures as someone else would.

Think about the editing workflow as an army boot camp. During the first few days, the army are looking to weed out the real no hopers and to most they will be obvious; after that it takes a few more weeks of hard toil before the natural soldiers begin to emerge, leaving the rest behind. At the end you have a fraction of the number that you did at the start. Editing is just the same. The end result of the workflow is a very small group of edited RAW files which you are going to keep, contained within which is a much smaller group of the ones that you will process called the 'best of the best'; these will be small in number in comparison to the large group in the recycle bin.

It is worth considering the transferability of editing metadata, such as stars between programs. It should work, but cannot be guaranteed.

Editing workflow preliminaries

There are a couple of preliminary steps that you may need to consider before starting the editing in earnest, these are included for completeness, as some users may find them invaluable:

DNG conversion

If you have not converted your RAW files into DNG format during the download stage, perhaps because your chosen software does not support this function, then this is the time to do it if you want a DNG workflow. Adobe provides a really useful, easy-to-use and free RAW-to-DNG converter that can be downloaded from www.adobe.com.

Initial back-up

Some users like to backup their RAW files at this stage to either CD or DVD, or an external hard drive. Of course, making back-ups is never a bad thing and you should do this if you want to, but remember you are about to delete in excess of 90% of these files during the edit. So whether you take a back-up now or not depends on how soon you are going to do the edit; if you are not

Right *A simple screenshot to show how RAW files can be colour coded during the editing process.*

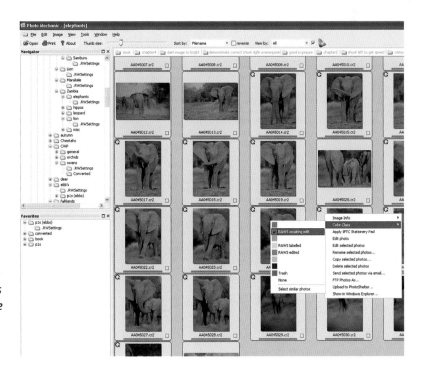

Left *The purpose of the editing process is to find the 'best of the best' such as this shot of a female green turtle (Chelonius mydas) shot in the early morning light on Ascension Island*

going to do it immediately, then a back-up cannot hurt; otherwise just wait until the editing is complete. Also consider that if you have just downloaded your RAW files from a downloader or a storage card, then you will have a back-up right there until you hit the format button. This is another reason for using a decent downloader with a back-up function, you will already have a back-up in this case, albeit not a permanent one.

Below *When using a slideshow for editing, it is important to do it with the intention of only keeping the best images. Although this image shows the wonderful wandering albatross courtship dance, I had others in the sequence that were better. Therefore it had to go.*

Editing workflow step one – the slideshow

The workflow starts by identifying and deleting the really bad RAW files, those that are out of focus or just plain awful. The easiest way of doing this is to show the image full screen; most RAW software has a slideshow application that will let you do this. If not then just keep one hand on the mouse and one on the delete key. Remember the main purpose of this step is to cut down the number of images by removing the trash, and here are some tips to help you on your way:

Right *An example of the RGB spot meter, while this image at first appears overexposed, the histogram is not quite against the right-hand axis, so detail has not been lost. The spot meter confirms that the brightest point on the chest is 249, which is bright but still recoverable.*

Focus

If a shot is out of focus, and you did not intend it to be, then delete it without a second thought. Don't think that you can spend hours on it making it look better, you can't. Also don't think that sharpening can resurrect it – all sharpening can do is make an in-focus image look better, it can do nothing about out-of-focus images. Send it to the recycle bin.

Similars

We all take groups of images that are virtually identical, and our editing workflow needs to pick the best and delete the rest. If it is not immediately obvious to the eye, then do not delete anything now as the next step is targeted at picking them out. However, don't forget that photography tells a story and although the individual image may be weak when viewed by itself, as part of a sequence it may tell a story and should be kept.

Exposure

Some images in a collection will be perfectly exposed, some will be far too dark and some will be too light. The previous chapter spoke about the 'shoot left' and 'shoot right' exposure techniques, and the point was

made that a dark image can almost always be recovered (unless it is practically black). RAW files that are overexposed present more of a problem, as it can be difficult to judge with the naked eye whether it can be recovered or not. If you find such an image, then use the tools that are usually provided by most RAW software to see if it is recoverable before you delete it:

Histogram If there is a peak up against the right-hand axis and little else, then the image is probably unrecoverable. If you have an exposure-correction slider on the same screen, then simply move it to the left to darken the image; if the peak stays against the right-hand side, then it is definitely unrecoverable.

RGB spot meters Some RAW programs have RGB spot meters to measure the RGB values at a certain point in the image. If you have this facility, then move the spot meter over the brightest area of the image; if it shows consistent values of 255, then there is no detail there and it could be burnt out. Of course it is up to you to decide if this actually detracts from an otherwise great image, if not then ignore it and move on.

Clipping warnings Most RAW software has some kind of flashing warning option to alert you to clipped highlights and shadows — for now I tend to keep this turned off, although it can prove useful later. A degree of clipping can always be corrected when you are shooting in a RAW format, and anyway, now is not the best time to decide if it ruins an image or not.

Try to allocate enough time to complete this stage in one sitting, you should only be spending seconds on each image and will get quicker the more experienced you become. At the end of step one, the number of RAWs in the collection will be cut by at least half. The biggest reduction, however, comes during step two.

Below *Comparing two images side by side in an image browser allows you to pick the best. Magnifying up to 100% shows that the right-hand image has more open eyes and is therefore the one to get the star rating; the other is deleted straight away.*

Editing workflow step two – editing similars

The next stage of the editing workflow is to take a look at the hundreds of similar images that we all take. Again, we need to bear the motto of our workflow in mind: to keep the best and delete the rest. Therefore in this part of the workflow we are looking at keeping the best in an identical sequence and here are some tips to achieve this.

Tiling

The best way of evaluating sister images is to compare them against each other like-for-like. Fortunately most RAW software now offers a tiling or comparison function, with which you can display two, three or four RAW files side by side to see which is the best. Be warned, however, that this is a very memory-hungry function and you will need at least 1GB of

Preview for 83DS9790.TIF (288 x 192 8641K) 100% ZOOM and 83DS9791.TIF (288 x 192 8723K) 100% ZOOM

RAM to do this consistently without causing your computer to crash. If you do not have a tiling function in your software, then just pick an area of the image where you can see a lot of detail and quickly swap between each image looking at the same point. If you cannot see a difference, then they are either equally good, or equally bad!

Focus

When you are comparing images, the crucial first step is to zoom all images up to 100% and view the portion of the image to which the viewer's eye will go first. For a live subject this will always be the face and the eyes, whereas for landscapes it is a good idea to pick either the foreground interest or a specific element of the scene.

Picking the best

If my sequences are anything to go by, then you will quickly see that one image should stand out from the others, and this is the one that you can keep. If the images are all identically sharp and identical in every other way, then just pick the first. Then, and this is very important, don't waste your time pouring over the rest of the sequence. If you have found a good image that is sharp, then it is pointless to waste time at this stage, otherwise you will run out of time later in the workflow, just press the delete key and move on to the next sequence.

At the end of step two, you should have cut down the collection drastically and be left with a small number of edited RAWs that you want to keep. Now it is time for the penultimate stage of the editing workflow, finding the 'best of the best'.

Below *Here four identical images are displayed together to find the best. The bottom right is clearly out of focus, but there is nothing to separate the first three so just I just picked the first and deleted the rest.*

Editing workflow step three – finding the best of the best

Within your edited RAWs, there will be a few which stand out from the rest. Usually you have already identified these during the two previous steps as they are the most eye-catching; the trick now is to somehow separate them from the rest without moving them on the disk. This is because it is important to keep all the edited RAWs together from the shoot, so that they may be backed up together and also catalogued together if required. This small group will be known as our 'best of the best' collection for the remainder of this book as it will allow us to easily track these images through the workflow. Lots of RAW software applications and image browsers use a rating system to separate images in the same directory, without physically moving them; the basic idea is that you can assign either a colour or a numbering system, often using a system of stars that will be familiar to users of iTunes. This is a great idea as it allows you to prioritize your workflow from this point on. While it is everyone's intention to process every RAW file in their collection, time constraints rarely allow this and in truth it is usually only the best of the best that will ever get colour corrected.

Below *This RAW file clearly stands out from the rest and so it is being assigned a colour tag accordingly.*

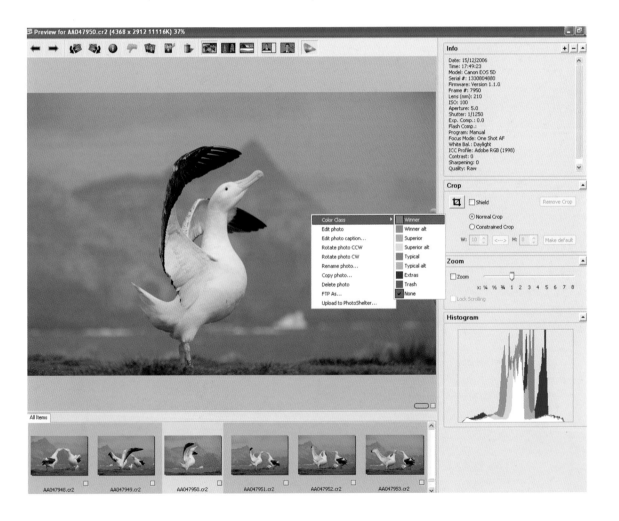

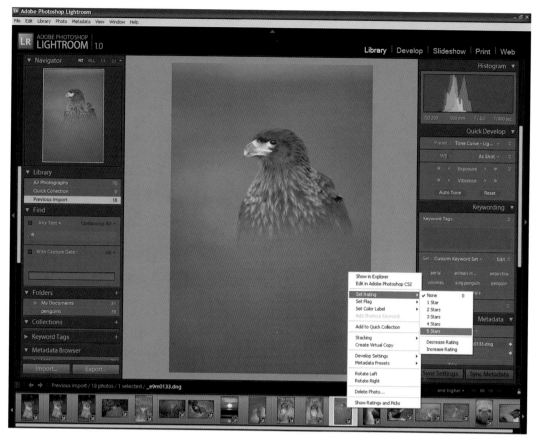

Housekeeping

There are a few minor yet incredibly important tasks that you now need to consider before getting to the heady heights of colour correction:

Download

If you edited the RAW collection directly from a downloader, then now is the time to copy the edited RAWs onto the workstation using the techniques and considerations described previously.

Renaming

This is a vital step, as it removes the chance of an accidental overwrite with a freshly downloaded batch of images. Some photographers do this when they download images before editing; that is fine, but it wastes a lot of numbers (since you

will be deleting most of them). When renaming you should use a naming standard of your own design which is simple, yet foolproof, the most common is to use Annnnnnn where A is fixed and nnnnnnn is a sequence number from 0000000 to 9999999. Most RAW software applications and image browsers have a renaming application that allows you to specify your own naming standard and a sequence number to go with it; the cleverest of them even store away the last sequence number used to ensure that the next batch starts from the correct place. If your software does not do this, then as an extra safeguard create a text file with the last number used and save it away.

Back-up

Now that you have edited and renamed your RAW files, you might want to take the first proper back-up to keep them safe. This is usually to a DVD or to a removable hard drive, which both have the advantage of being cheap and easy to use; they are also storing images away from the workstation which is a good

PRO Tip

I back-up at this stage to both DVD and a removable hard drive. In fact I have two identical hard drives for my RAW files, so I have extra security in case one fails. This has paid dividends on a few occasions. It may seem paranoid, but images are my business and storage is cheap.

Below *Once the editing is complete, then the 'best of the best' RAWs (note only four) are being renamed with a renaming mask comprising the fixed letters AA and a six-digit sequence number starting at 48000.*

idea. If you want an online system, then a RAID storage array is the one to go for, but this is expensive and can be complex to set up for the new user. Remember also that although we are just going to correct the best of the best RAWs, you will back-up all of the edited RAWs as you never know when you might want them.

Tidy up

After one final check to see if you have made any slips, delete the RAWs in the recycle bin, as they will still be clogging up space.

Below *Using Photo Mechanic, this RAW file is being keyworded and having caption information attached; this will accompany the image wherever it is distributed around the world and clearly identifies the owner.*

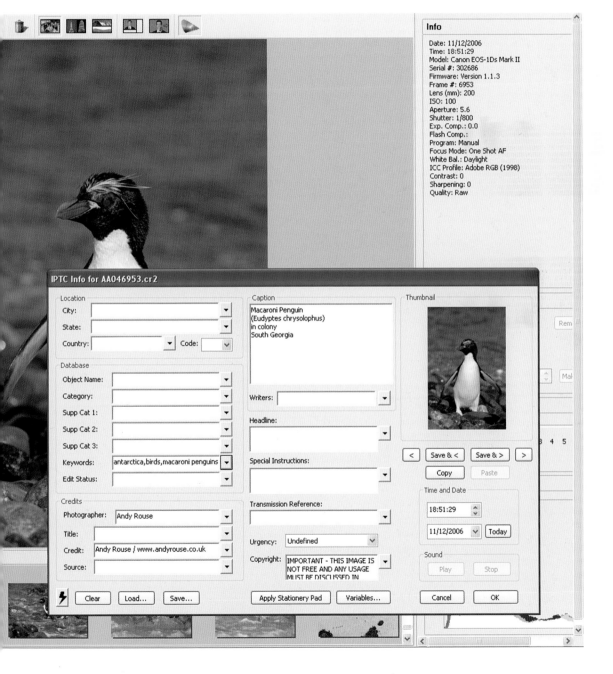

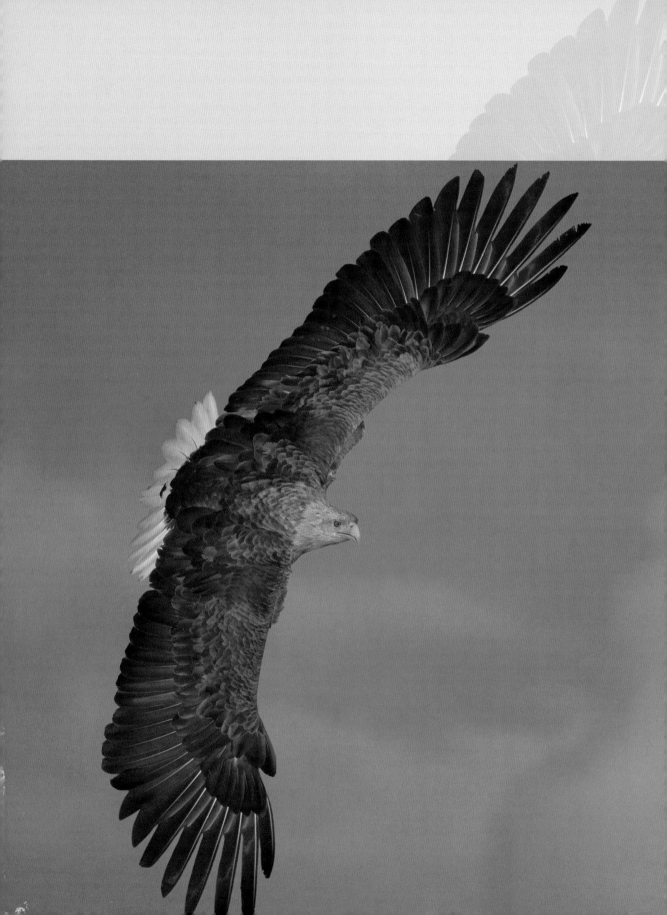

RAW correction and processing

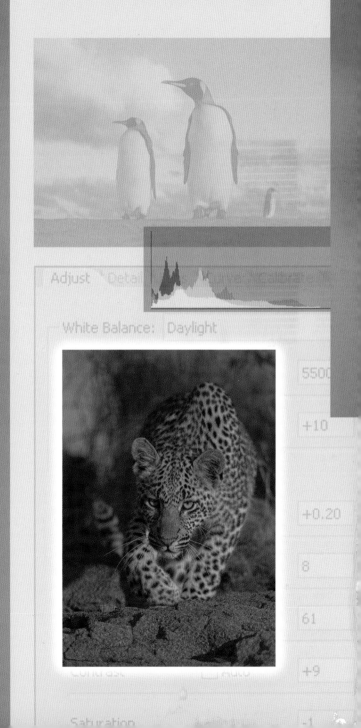

Before going any further, let's recap on what has happened so far in the workflow. It began 'in-camera' with the initial set-up and ensuring that you get the best possible exposure. Then in chapter three you edited your RAW collection, using various techniques, to cut down the number vastly to find the best of the best. After a quick bit of renaming and back-up work, you can now correct and process your files.

Basic correction

This chapter will show you how to take the best of the best collection and make it into something really special. The purpose of this chapter is to show you how easy it is to apply quite sophisticated corrections, both in terms of colour and formatting, to your RAW images. It does not take much technical knowledge and there is no right or wrong way to do it, you can be as creative as you like! Once they are colour corrected and formatted, your RAWs can now be backed up (if you did not do this previously) before moving onto the next stage. The end of the chapter then concentrates on taking your colour-corrected and formatted 'best of the best' RAWs into the real world, by suggesting various workflows for printing, email, web galleries and post processing.

At this point most photographers have an opinion of how the workflow should progress. This chapter should therefore be seen as a starting point, a building block that inexperienced users can use to get started and more experienced users can pick up some tips from to fine-tune their workflows. Either way the basic approach is a simple one that follows the principle of the chapters so far, treat each shoot individually and process it accordingly. Therefore when you come to process your best of the best RAWs, the logical step is to apply the colour and formatting changes to each RAW in turn until you have completed the whole lot (which should not be more than a handful of files anyway). Then you can decide whether you want to back-up, or perhaps catalogue, before moving onto the output stage.

Right *The basic corrections such as exposure, contrast, white balance and are the key to getting a good result, such as this African leopard (Panthera pardus) stalking.*

The basics

Let's start with the basics – you can correct as much, or as little, as you want to, it is a personal choice. If your image is close to being correctly exposed, and in reasonable light, all you will need to do is generally make a couple of small, quick changes that will take seconds. Of course, you may feel that your image needs a lot of corrections, and if this is the case, then you can go wild as modern RAW software has a wealth of possibilities when it comes to applying corrections.

The one over-riding fact that I teach everyone on my courses is that you do not have to make any corrections if you do not want to. If you like the look of the image and are happy with it as it was shot, then feel free to skip this chapter totally. I would say, however, that most RAW files in my experience benefit from a little tweaking here and there.

◎ **The bottom line**

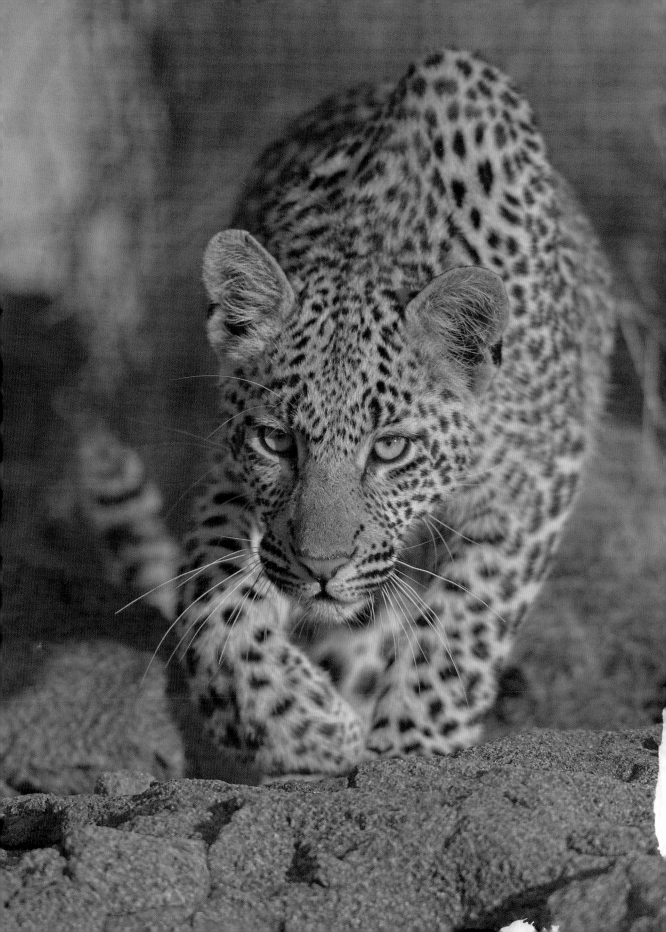

Before jumping in at the deep end, it pays to understand just how your RAW software stores the changes that you make. The first time that your RAW file is displayed, the software uses the shooting parameters (for example, white balance, saturation and so on) that were recorded when it was shot. If you decide that they are perfect and require no changes at all, then the RAW file will be displayed using these parameters until you decide to make a change. When you do make changes, most RAW software saves the details away in a small external file; it creates this file the first time you make the changes and always looks for its existence before looking for the default shooting parameters. When you make changes, these are automatically saved by the software, you do not have to save anything yourself. It is really that easy.

The only caveat comes if you start moving your files around. This is fine if you use your RAW software to perform the moves, as it will then know where to look

for them. Just remember that correcting RAW files is much like the art of photography itself, and it is vital that you experiment.

PRO Tip

As I have already said, there is no penalty for applying countless corrections to your RAW files, well that is not completely true. It is very tempting to 'overcook' a RAW file and make it look completely false. You cannot, for example, create a beautiful sunset when there wasn't one, or make a cloudy day look sunny. I perform my corrections with the following philosophy – to make the final image look like I remembered seeing it at the time. I don't fiddle excessively with the colour (apart from having a bit of a fascination with saturation) and this gives me a well-balanced image that I can either send to clients, or use as a starting point for some more selective colour changes in Photoshop. Either way the final image is a true one.

Below *A typical RAW conversion screen showing all the essential elements. The results of moving the correction sliders are instantly shown on the preview and each should be nudged as appropriate.*

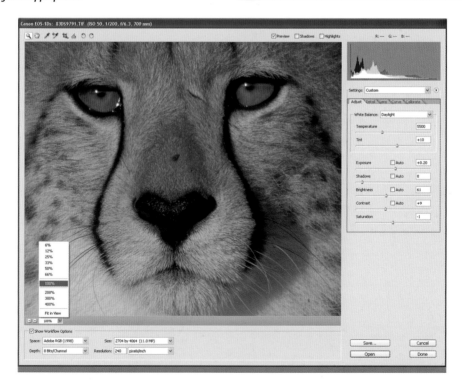

Vital tools and techniques

With all the foundations laid, now is the time to start making those corrections. Most RAW software makes this very easy for you, with each correction requiring no more than moving a slider with a mouse. The effects of any changes are seen instantly on an adjacent preview of the image, which can usually be magnified by several hundred percent; these changes can be instantly removed by just resetting the slider. It's really that simple, if you don't like what you have done, then you can simply change the value of a single correction tool or in fact the whole lot. If you decide to reset, then the display will revert to the original parameters.

Before getting into the practicalities of correcting your RAW files, it is perhaps best to give an overview of the most common correction tools that you have at your disposal. This is by no means an exhaustive list, since more are being added with each software release, but those on the list are the ones that really count. To be honest, a lot of photographers only correct exposure, occasionally the white balance and tweak the saturation, so, to them, much of this may seem redundant. Of course, it is your choice, but this section does give some useful advice on

different tools, and the more you know, the more that you can correct. Remember, correcting a RAW file requires no prior knowledge of the technicalities that lie beneath the correction tool; if you do not understand what it does, simply try the tool and you will see for yourself.

Adjusting the black and white points

Sometimes the camera sensor fails to record all the areas of brightness that it can, and creates a histogram with gaps between either end and the extremes of the dynamic range. Removing these gaps allows the histogram to cover all the levels of brightness available and the image will look better for it, in fact the change after removing these gaps can be amazing.

To remove the gaps, you will need your RAW software to either support a 'levels' style function such as that in Photoshop, or to have individual sliders for the black and white points. The latter is self-explanatory, and playing around with the sliders will

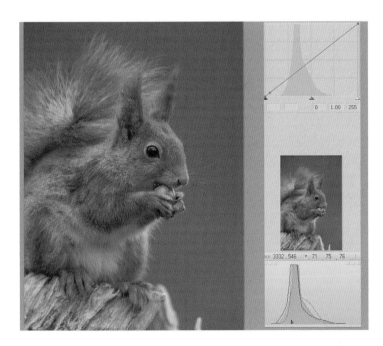

Left *You can see the two gaps in the histogram at the top of the screengrab which need to be adjusted to get the most from the image.*

allow you to see their effect; but the former perhaps needs a little explanation for those who are unfamiliar with the technique of doing this in Photoshop.

1. To the top and the right of the screengrabs is the basic levels dialogue box, a version of which you see in most RAW software and in Photoshop; it is essentially the same as the histogram that you see on the back of your digital camera, but in this case you are able to adjust the output for each input level.

Notice the gaps between the histogram and the left and right limits of the horizontal axis on the screengrab on page 73 – it is these that we are going to fix. First, it pays to take a close look at the histogram and decide where the tones actually start to be recorded; be careful to check if there is a very thin line of pixels stretching from the main histogram to each axis, if so then skip this step completely as it does not need correction. If there is a definite gap, then do the following:

2. As shown in the screengrab to the right, move the left-hand slider under the histogram until slightly before the histogram starts. This is the black point set and now the image is showing the black end of the histogram as detail.

3. Repeat the same for the white point with the right-hand slider. As you drag the slider to the right you will see the image get progressively brighter, it is important to set the point just before the histogram starts as you may run the risk of burning out highlights.

4. Once you have set both points, you may find that the image looks a little odd and this is usually because you have set the left-hand slider (the black point) too far towards the middle of the histogram. Back off slightly until the image looks more natural.

5. Now you might be thinking 'what a shame there is no indicator for when the black and white points have been correctly set'. Well, actually there is: the clipping warning. Clipping occurs where the range of brightness in your image falls outside the profile that you are working with or the dynamic range of the sensor.

Below *The left-hand slider has been moved inwards to meet the point at which the tones begin.*

Top opposite *With the clipping warning switched on, the left-hand slider under the histogram is moved until the clipping warnings show. Then it is moved back towards the left-hand side. The same is then done for the right-hand slider until the clipping warnings show, then again it is moved back towards the right-hand side.*

Bottom opposite *Moving the sliders to their final positions, with no clipping of either highlights or shadows, gives the final result shown here. Incidentally, the image also shows the results of an incorrect white balance on a cloudy day, this should have been corrected first, but we all make mistakes!*

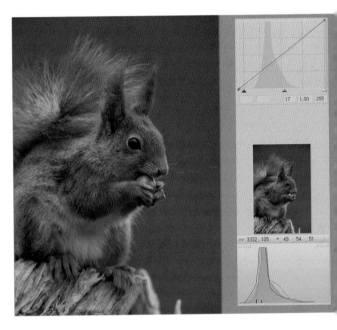

In plain English, it will tell you when the black and white points are set at the right level. Examples of this are shown in the screengrabs at the top of the facing page.

6. Once you have corrected the exposure, paying attention to any clipping warnings, you should have a more balanced image that will usually show a huge improvement. In some cases though, the effect is too strong and you will have to back off until the image suits your tastes. This method is not perfect, but often it will be all you need to do; since you are not clipping the working space any more you will also find that any prints you make will have a better range of colours.

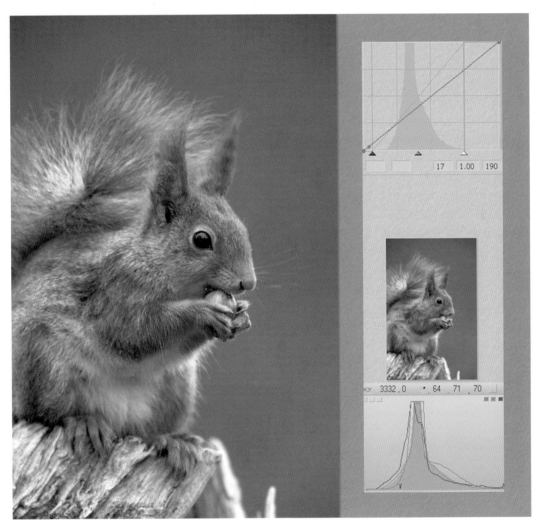

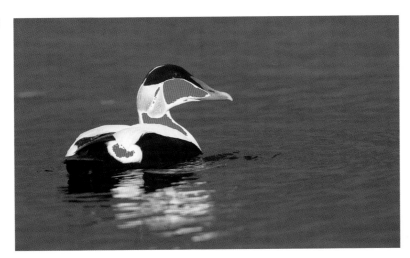

Left *The clipping warning works differently in each piece of software, here it shows the overexposure in red.*

Exposure correction

The quick and easy method of correcting exposure is to simply move the exposure slider that all RAW software provides as standard. This may seem like a simple procedure, but there are a few points to note:

If you use the 'shoot left' technique for exposure (see page 39), then your histogram will usually be biased to the left of centre and you will need to increase the exposure (brighten the image) accordingly. When compensating the exposure in this way, it pays to be aware that you will also be increasing the visibility of any noise in the dark areas of your image. This is one of the side effects of the 'shoot left' technique. Noise can ruin an image, especially if it is of the multi-coloured variety, and it always pays to inspect your image thoroughly at 100% magnification before proceeding any further. Noise can be suppressed by most RAW software, using custom-designed noise-suppression sliders, but the effect of these tools is global and you will be

removing detail from parts of the image that do not have any noise. It is therefore best to strike a compromise at this stage between increasing the exposure and keeping the noise at an acceptable level; post-processing tools such as Photoshop will allow you to mask these noisy areas and apply specialist noise-reduction applications to them without affecting the rest of the image.

If your image is overexposed (or you used the shoot-right technique) then you will have to use a combination of several sliders to get a usable image; this will be discussed later (see page 95).

If you have set the black and white points as discussed previously, then changing the exposure settings may give an unnatural effect. This is easily corrected by adjusting the offending point to bring it outside the new histogram; the balance between the two is a compromise so a tweak here and there will get you what you need.

There is no doubt though that there are few images where the exposure slider will not be nudged just a little, it is perhaps the most commonly used of all the correction tools.

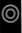 **PRO Tip**

I always use the clipping warning tools as it allows me to quickly set the black and white points. In fact for some of my images this is all I need to do as the improvement is so marked.

Correcting white balance

Most digital cameras set the white balance reasonably accurately, so you will often not need to correct it. If, however, the image looks as if it has an odd colour cast, then it might be caused by an incorrect white balance; you can remove this by using one of several commonly supplied RAW tools:

Presets Some RAW software provides a drop-down list of white-balance presets to match what you have on your camera. If you find that you have an incorrect white balance, perhaps because you shot on 'auto' under artificial indoor light (when the image will often be blue), then simply selecting a white balance of

'tungsten' or 'fluorescent' will give a much better looking image. Beware though if you are selecting the 'cloudy' white balance, this can give a very unpleasant orange colour cast, which will do little to show your image in the best light.

Eyedropper An eyedropper tool is sometimes provided, which allows you to select a neutral area of the image to set a custom white balance. Neutral

Below *One of the great benefits of RAW is that you do not have to worry about the white balance too much. If it looks wrong, or you want to experiment, then just use the drop-down slider and check out the effect on the preview image.*

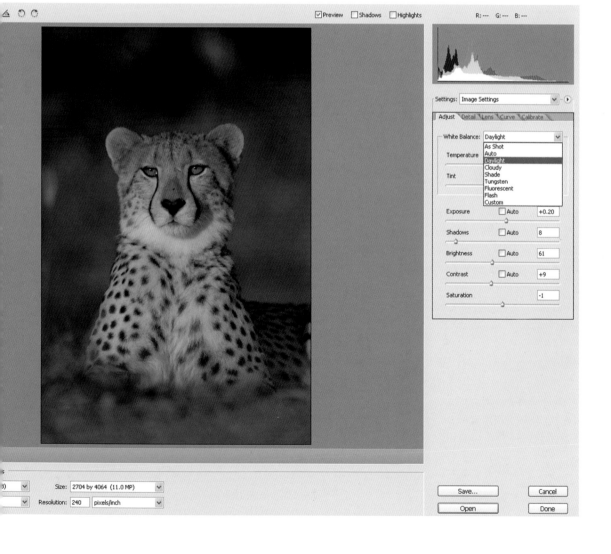

simply means an area without extremes of colour, in other words something that is midtone grey. This takes some practice to get right, but for a few RAWs in a thousand this will be the best method.

Sliders Use the white-balance (sometimes called colour temperature) sliders to change the white balance of the image incrementally. This is the most flexible, easiest and quickest method.

Correcting contrast

Contrast is the difference between the darkest pixels and the lightest, and if altered subtly can greatly improve the look of an image. On the other hand it can really destroy it! Most RAW software has several different methods of controlling contrast and the best trick as always is to suck it and see which works best for you.

Simple method – contrast sliders

Sliders are generally the easiest way of applying corrections, they allow you to view the effects of the changes as they are being made, making them both convenient and accurate.

General contrast slider Sometimes just a single slider is provided, which should be treated with extreme caution and only used sparingly as it is difficult to be precise when making alterations with just one slider. If you are in this situation, then it will often be a lot better to open the converted RAW file in Photoshop and finish editing it there, with more powerful contrast controls such as curves.

Highlight contrast slider This slider can go some way to recovering white, featureless skies that occur when the range of brightness between the land and the sky is too great for the camera to record both well. Dragging the highlight contrast slider towards

increasingly lower values, in other words reducing the contrast, will bring back some detail in the sky. Note, however, that this will also affect any highlights in the main subject area so it needs to be used with caution; overdoing it will make the whole picture look false. If in doubt just apply a little highlight contrast correction and do the rest in Photoshop.

Shadow contrast slider This slider controls the contrast between the shadow areas and their surroundings. Some images benefit from a little shadow contrast adjustment so it is best to experiment, often a little positive shadow contrast will improve the visual impact of an image and make it look less washed out.

Advanced method – curves

The above slider-based tools are great for most contrast corrections, but the most powerful tool is 'curves'. The simple way to explain curves is that it can improve the visual 'punch' of any image and even allow you to make powerful adjustments to one part of the image without affecting anything else. The results can be seen instantly, can be immediately reversed and often a single curve can magically transform an insipid image into something of which you can be proud. There are two quick techniques for using curves:

Midtone curve Click on the centre of the curve and drag it downwards (towards the corner) to darken the image or upwards to brighten it. As you have grabbed the centre of the curve you are changing the midtones of the image, while changing the highlights and shadows (the top and bottom of the curve) to a much lesser degree. This is particularly important with highlights as they must be kept from burning out at all stages of the conversion process.

S-shaped curve The s-shaped curve is the standard one that is used by experienced users as it allows very

Right *Tricky subjects such as this puffin – shot on Fair Isle, Shetland Islands, UK – with its extremes of black and white are best suited to advanced contrast correction using curves.*

subtle control of both highlights and shadows. Simply click once at the bottom-left quarter and once again in the top-right quarter as shown opposite.

This fixes two points. Moving the top point controls the highlights while the bottom point controls the shadows, just try it and you will see. In fact you can have multiple fixed points on the curve, but this can end up looking like modern art, so for most of your work just stick with one or two.

Curves are a great correction tool and are incredibly powerful, they just take a bit of experimentation, that is all; and as you are working with RAW files, which you can simply revert to the original settings, this presents no problem at all. If you are not sure how to use curves, then some RAW software offers preset curves such as 'medium contrast' or 'linear' that are a very good starting point for some more inexperienced users.

Right *A pretty flat image before adjustments using an s-shaped curve, this has added contrast without losing detail and has vastly improved the image.*

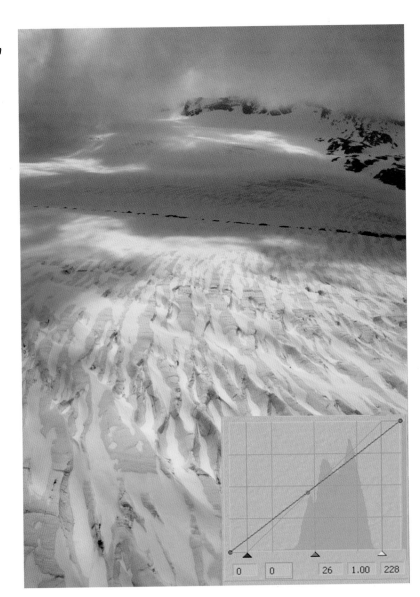

Far right *There you are, a quick bendy curve gives a lovely moody image.*

Correcting saturation

Saturation has the effect of warming up an image to give it a more pleasing look. Some digital photographers are addicted to saturation; in fact they are obsessed by it. There is no doubt that a small boost to saturation can greatly improve an image, but equally an overdose of it can ruin it in the following ways:

Increasing the saturation will also increase the visibility of any coloured noise that is present within the image. This will particularly manifest itself in areas of diffuse colour, dark shadow detail or blue skies. Colour noise can be removed, of course, by using sophisticated plug-ins, but this all takes time.

Saturation sliders increase the saturation across the whole of the image equally, this means that areas which are already saturated will become completely over-saturated. Some of the more advanced RAW software tools such as Adobe's Photoshop Lightroom and Adobe Camera RAW have a selective saturation function called 'vibrance'. This is an awesome tool, which only saturates areas that are in need of it and leaves parts of the image unchanged. It has to be seen to be believed.

The bottom line with saturation is to be careful, and to remember the philosophy that you are only correcting the image back to a colour that is close to what you first saw with the naked eye. Adding saturation on a sunny day will certainly make the image look better, but on a cloudy day it will have an artificial effect.

Left *A little bit of saturation has been added to this shot of king penguins and has added life to this sunset scene, captured in the Falkland Islands*

PRO Tip

Desaturating an image is a good starting point for converting it into black & white. Simply move the saturation slider to 0 and the image will become black & white. Then you will need to adjust the contrast (best done using curves) as the best black & white images are all about getting the contrast just right. I often do this with high-contrast images that do not work in colour.

Below *Scenes with interesting contrast make for good black & white images, such as aerial shot of Warburton Peak, South Georgia, Antarctica.*

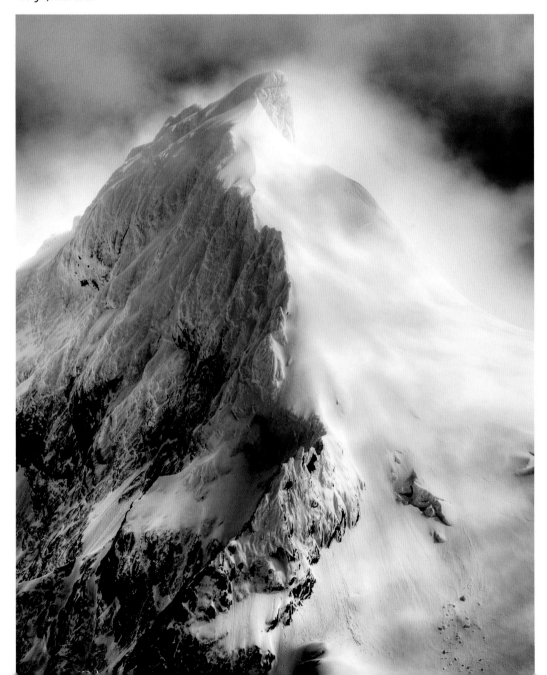

Above *A good example of when the 'before and after function' is at its most useful.*

Sharpening (or not)

Sharpening is a much-misused tool, as it is too often seen as a way of saving a poorly focused image. If your image is out of focus, then sharpening cannot make it look better, the only thing that can is to take it again!

A little sharpening on an image, however, can improve its visual impact, but this needs to be undertaken with care. Usually this is a nudge on a slider rather that a large movement and you should be viewing the image at 100% when applying the sharpening, in order to see how much it is affecting the edges of the image. Note that it will also make any noise stand out more.

How you use it depends on what your next step is after colour correction. If you are going to undertake some extra post-processing in Photoshop, then I suggest that you sharpen just a small amount (typically at the default level) at the RAW stage of the workflow and apply the main sharpening in

Photoshop, after you have done everything else. If, however, you are fortunate enough to have one of the latest generation of RAW programs that allow direct printing from a RAW file, then you will need to sharpen at this stage of your workflow.

Advanced features

The complexity of RAW software has increased to the level now where it can perform many of the functions of sophisticated applications such as Photoshop, including:

'Before and after' views

Some RAW software has a 'before and after' view so you can compare the effects of your changes with the original. This is useful to show if you have gone too far with corrections and they look unnatural. If they do, then just apply less, remember nothing is permanent.

Above The stacks tool in Aperture has twin purposes, its initial function is to group images as they have been shot. This can be done automatically in which case it is based on the time at which they were shot. Alternatively, it can be used to group together variations of the same file, for example, in the screengrab above the different crops made of the same stag image have been grouped together.

Above and right The original image was severely underexposed and the histogram is a long way to the left. A good indication of whether it can be recovered is whether the automatic correction offered by the software can render a usable image. The screengrab to the right shows that it can and this gives a good starting point for any fine tuning or subsequent corrections.

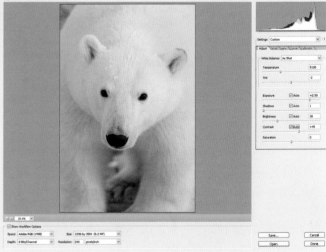

Stacks/variations

This feature allows to you to group different images together in stacks of images. Programs like Aperture are able to do this automatically using parameters such as the time that they where shot; however, you will often need to make alterations manually. This is a particularly good way of of managing files that are variations on a theme, or sequences of images.

Auto correct

Some tools have an auto-correct function, where the software evaluates the image and makes corrections for you. This should be seen as a starting point rather than the complete solution and is a good first step if you are not experienced at making corrections. Just remember though, that the software has no idea what end result you want so it will apply a relatively generic set of 'improvements'.

Colour-channel corrections

Adjusting the individual colour channels – red, green and blue – is usually done via a combination of sliders. However, this will have a global effect and is often better left to programs such as Photoshop in which you can apply local changes.

Lens correction

This used to be only possible using specialist software, but tools for the correction of vignetting, chromatic aberration, barrel and pincushion distortion, and even the correction of perspective as well as other lens-induced errors are starting to appear within RAW software. These tools are particularly important for users of super-wideangle lenses or for those photographers who specialize in buildings and architecture that require critical corrections.

Dust-spot removal

Originally the domain of post-processing software, dust spot removal is now being offered by an increasing number of RAW software applications. Admittedly in most cases it is much less sophisticated than the latest Photoshop tools, but for some images it will be good enough, particularly if they are to be printed directly from RAW. Also included under this heading in certain RAW converters is the option to apply dust data, in order to remove dust spots detected by the camera automatically.

Below *A close-up of some nasty dust spots that needed to be removed before printing.*

Above *The dust spots being removed using the Photoshop Lightroom healing brush function.*

Below *The final result, with the dust spots removed and with indications of where work has been done.*

Black & white conversion

The wonderful medium of black & white photography is making a comeback, largely thanks to the flexibility of digital photography. It is very easy to convert your images into black & white within your RAW software. Although a full-blown post-processing package will offer you alternative ways of converting into black & white, there is still plenty you can do to your image in your RAW software:

Specialized profiles Some RAW software has black & white profiles supplied with it that perform the conversion from colour, just select them and the image will appear in black & white. Unless you have some very specialized black & white controls (such as contrast filters) in your RAW software, the main correction control that will be effective is curves.

Saturation If you do not have any specialized black & white profiles or tools then you can still get a decent black & white image by completely de-saturating the colour one. Just take the saturation slider and drag it all the way to the extreme where the image will be shown in black & white, you can then use the curves tool to make any additional adjustments.

 PRO Tip

There are a number of very sophisticated black & white tools that are supported by products such as Photoshop. For the serious black & white photographer, these provide all the darkroom-style functions that you will ever need, and it is these that I use to create my black & white art prints. Therefore my workflow in this case is to perform as much colour correction in the RAW software as possible, usually involving curves, and then convert the RAW into a high-resolution file, which I can process in Photoshop using one of the specialized tools.

Colour corrections While at first it might seem counter-intuitive, colour corrections still have a role to play within black & white photography. Changes to the white balance, levels, contrast and curves will all impact how the final image appears. The beauty of applying these changes at the RAW conversion stage is that they can be reversed simply and quickly.

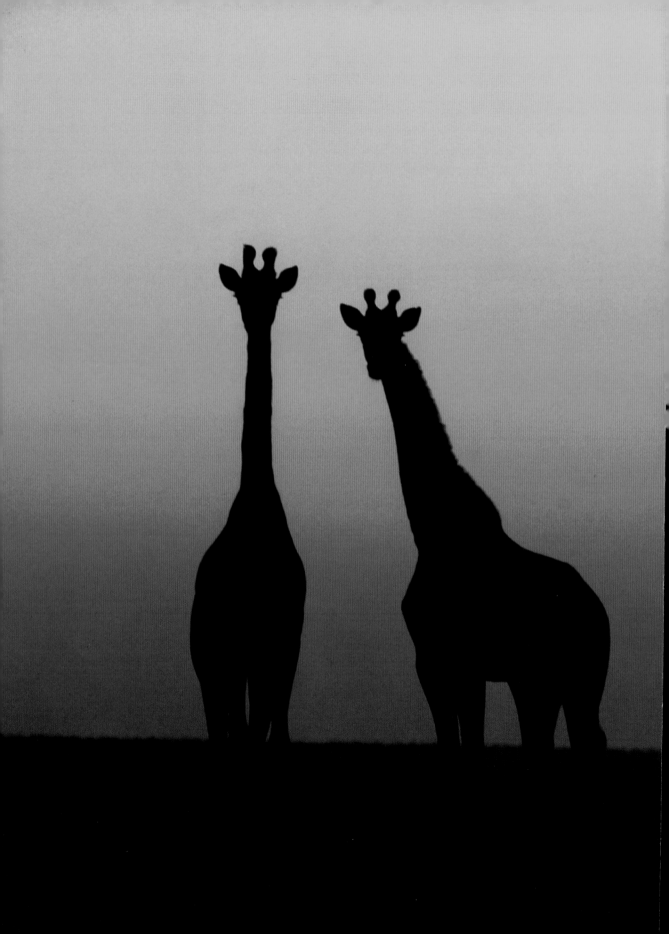

Practical considerations

OK, so now we've covered all the basic tools. Some users might now feel confident to continue on their own and make the appropriate corrections to their image, but it is my experience that many photographers require some extra guidance. Therefore the following section will suggest an approach to making corrections in a logical manner, which takes into account that any group of RAWs will contain images that vary in exposure and that photographers use different exposure techniques depending on the situation (see page 43).

The first step in the process is to sit back and look at your RAW file; ask yourself what you want to show in the picture and try to work out what needs to be changed before actually doing anything. Does it need to be darker, does it have an odd colour cast, does it need more warmth, is that bit of rock in the foreground distracting? Doing this will make you think about the image as a photograph, and not just a collection of sliders, and will ensure that you make the corrections that are best for the image.

The histogram

The histogram really is your greatest ally in the world of digital photography; not only did it help you get a decent exposure out in the field, but it will now govern how you approach making corrections to your images. Most RAW software displays the histogram for each RAW file somewhere on the correction panel so find it and learn how to inspect it.

Depending on how good your initial exposure was, and which shooting technique you used, your histogram will be a variant of one of the following histograms:

For each image the starting point is the same (correcting the white balance if required), but then there are subtle differences that will ensure that the end result is a decent image; it is not rocket science and will quickly become second nature.

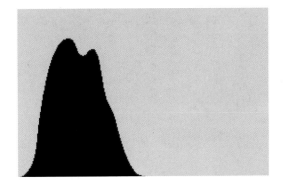

Right *Three typical histograms, as have been discussed earlier, showing a lot of bright pixels (top) a lot of midtone pixels (middle) and a lot of dark pixels (bottom); note that this can be for many reasons.*

Left *This silhouette of southern giraffes herd at sunset in South Africa would display a histogram that was shifted a long way to the left, with a number of pixels showing no detail in the shadows.*

Underexposed or 'shoot left' histogram

A histogram with its main peaks to the left of the centre will generally result in a dark image; this may have been as a result of poor exposure technique, a dark subject, or deliberate underexposure using the shoot-left technique to get a faster shutter speed or avoid blowing out the highlights. In any case, the following sequence should ensure a decent image at the end that is ready for the output stage:

First, correct the white balance. Now look at the histogram and decide if the histogram being to the left is a result of underexposure or simply the tonal balance of the image. If you decide that the reason the image has a histogram that is biased to the left is because it comprises mainly dark colours, then you may not need to apply any exposure compensation at all. Remember, you do not have to correct anything, photography is about self-expression and if you're happy with the tones of the image then just leave it as it is.

If the image is underexposed and the histogram has no gaps between the extremes of brightness shown and the possible dynamic range, then increase the exposure by using either the exposure-compensation slider or by creating a midtone curve.

If the histogram has any gaps, then in this case it will usually be between the right-hand tones and the dynamic range; if this is the case, then you can improve the image using the levels dialogue box along with the clipping-warning tool explained previously, see page 74. If you do find a gap to the left-hand side of the histogram, which can occur in certain circumstances, then correct this using the same technique.

Your image should already start looking a little better, so now you can apply the finishing touches. Set the contrast according to taste, usually underexposed images will need a little extra contrast, especially if you have bright skies in the image. For this you can either use the curves tool or just tweak the contrast sliders, it all depends on which RAW software you use.

Set the vibrance and/or saturation tools to taste, along with any specific colour-channel correction tools (which are used to remove any colour cast).

The final stage is to try to reduce the effects of any noise that can appear in the shadows when an underexposed image is brightened. The easiest way to check if you have this problem is to magnify the image to 100% and inspect the darkest areas of the image, also have a look at any featureless areas such as sky. Noise will manifest itself as multi-coloured dots and it is up to you to decide if it ruins your image or not. If it is barely apparent then leave it alone as a little noise doesn't hurt an image, but if you can clearly see it, then you may need to take one or several of the following steps:

- Use a noise-reduction slider to suppress the noise; only use the slider at very low values (such as one or two). Using noise reduction of any kind will effectively reduce the detail in the image as it is applied globally to all pixels in the image.

- Adjust the settings of both the levels and exposure-compensation sliders as you may be able to reduce the visual impact of the noise by reducing the settings of these sliders and having a slightly darker image overall.

- If the noise is excessive, which can happen if you have taken an underexposed image in poor light or at a high ISO, then it may be easier to leave it at this stage and reduce the noise in Photoshop. Using widely available noise-reduction plug-ins such as Noiseware or Noise Ninja you can apply noise reduction to those areas of the image that really need it and leave alone the areas that do not.

- Check to see if you have any sharpening applied to the image, as this can increase the appearance of noise in the shadows; if you have, then reducing it slightly can noticeably reduce the visible noise.

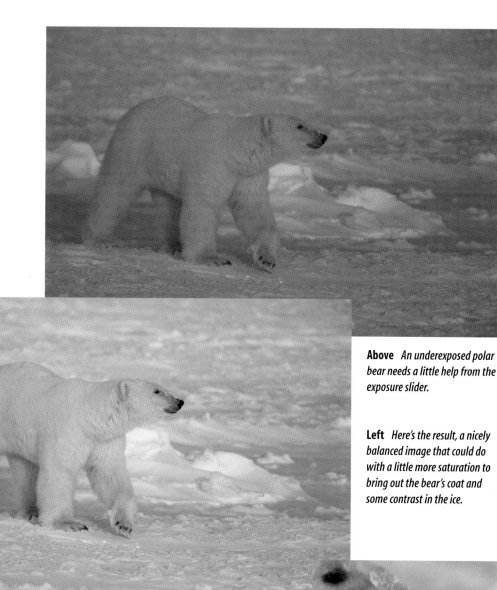

Above *An underexposed polar bear needs a little help from the exposure slider.*

Left *Here's the result, a nicely balanced image that could do with a little more saturation to bring out the bear's coat and some contrast in the ice.*

Above *Here's a closeup of the dark and dingy shadow areas. They show no noise so there is no need to perform any noise suppression.*

PRO Tip

Don't let the noise issue worry you into always shooting with a low ISO such as 100 or 200. The real beauty of a DSLR is that it will give you a usable image at much higher ISO values when otherwise you would have got nothing. I have shot in a dark Finnish forest at one o'clock in the morning at ISO 800 and still sold pictures from the shoot; so don't be afraid to trade a little noise in exchange for a sharper image. Remember it is all about getting the shot.

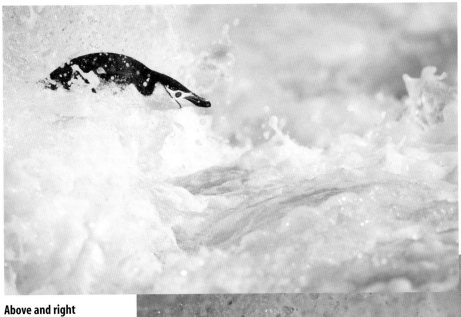

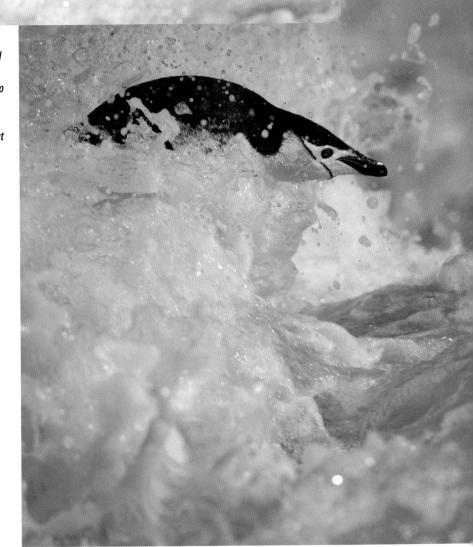

Above and right

An accidentally overexposed surfing chinstrap penguin that was nearly consigned to the recycle bin. After a few clicks, however, the result is a nicely balanced image that can now have some further contrast work performed to bring out the visual punch.

Overexposed or 'shoot right' histogram

A histogram with its main peaks to the right of the central midtone area will generally result in an overexposed image; this may have been as a result of poor exposure technique or deliberate overexposure using the 'shoot right' technique. Either way the following sequence should ensure a decent image at the end that is ready for the next stage:

Correct the white balance to taste. Now look at the histogram and decide if the histogram being to the right is a result of overexposure or simply the tonal balance of the image. To be honest, this is less likely

to happen than with the underexposed image shown previously, but it still needs to be mentioned as some photographers love to shoot overexposed images, and there are plenty of light or white subjects out there.

If you decide that the reason the image has a histogram that is biased to the right is because it comprises mainly of light colours, then you may not need to correct it at all. A little contrast may help add impact to the image though.

If the histogram has any gaps, then in this case they will usually be from the left-hand edge; if this is the case, then you can use the levels dialogue box and the clipping-warning tool to improve the image. If you do find a gap to the right-hand side of the histogram, which can occur in certain circumstances, then correct this using the same technique. Now move onto the next step.

Your image will probably not look a lot better at this stage, and will still look far too bright; this is OK, as all you have done is to set the highlight and shadow points correctly. The next stage, however, will make a huge difference.

Using the exposure-compensation slider, reduce the exposure until the image looks to be correctly exposed. This is best done in conjunction with the clipping-warning tool, and you will find a point where there is no clipping of the highlights. Sometimes, however, the very act of doing this will cause the shadow areas to show some clipping, which can be corrected by nudging the levels slider. A little fine-tuning is always necessary, and with experience this can be done in a matter of seconds. Now the image should look much better.

If any overexposure is still showing then part of the image may be so burnt out correction is not possible. Before deleting it try one of the new highlight recovery tools in products like Lightroom and Aperture as they can perform wonders. Finally before throwing it away ask yourself if it detracts from the picture, if it doesn't then keep it. If not then delete it and move on.

Now set the contrast to taste, then make any changes necessary to the vibrance or saturation tools, along with any specific colour-channel corrections.

There is no need to perform any noise suppression for this image as the 'shoot right' technique should ensure that there is very little noise, even at high ISOs.

Bell curve – centre histogram

A histogram with its main peaks in the centre, with a good spread to either side, generally indicates a well-exposed image, in most situations, that will need little correction. The following sequence will gently enhance the image, but the changes needed are generally fewer than for the two previous stages.

Correct the white balance to taste. If the histogram has any gaps, then correct these with the levels dialogue box and the clipping-warning tool. Use the exposure-compensation slider and the curves tool to make any slight changes to exposure that might be necessary.

Set the contrast according to taste, then make any amendments required for the vibrance or saturation tools, along with any specific colour-channel-correction tools. It may pay to magnify the shadow areas of the image to check for any noise and to suppress it if necessary; in this case though this suppression will only be at a very slight level and usually none is needed at all.

The journey so far...

So, by now you can see how easy it is to apply quite sophisticated corrections to your RAW files, and to recover images that at first glance appear far to dark or far too bright. If you have followed the workflow this far then you will have moved through the best of the best collection and colour-corrected everything to the best of your ability. Remember, if you decide that you don't like the colour, then just change it, it will have no permanent effect on the RAW file. The next stage is to correct the composition of the image by cropping it and straightening any horizons that are a little wayward.

Composition

While we all try to take perfectly composed images in-camera, it rarely transpires that we get the image exactly as we would like it. A common culprit is including too much space around the frame, something which can be fixed by cropping. Most RAW software now provides a pretty good crop tool that either lets you decide the boundaries of your new image or makes you adhere to a set output size; a common one is to have a crop for a 10 x 8in print. If your software does not have a crop tool, then it is not an issue, as all good post-processing software has brilliant cropping tools, so simply do it there.

The one big thing to remember when cropping is that you are reducing the output size of your image by doing this, which may affect the size of the print that you intend to make. So hand in hand with cropping goes the need to interpolate or re-size the image back to its original size; this will be dealt with later (see page 115).

Backing up your RAW files

Now your 'best of the best' RAWs have all been colour corrected and formatted it is a good time to consider making a decent permanent back-up to either CD or DVD, external hard drives or a RAID system. The main advantage of making the back-up now, as opposed to before this chapter began (in other words after the editing step of the workflow), is simply that the colour and composition changes that you have made will now be stored in the RAW software's colour file. If you back this up now then all of your changes will be stored with the RAW file for future use. RAW software applications vary in how they handle this, some require you to find and move the colour file yourself while others move the colour file for you at the same time as its associated RAW file provided that you perform the move using drag-and-drop features of the RAW software in question as opposed to going outside the program and using the operating system.

Of course, the situation with DNG is a little different as there is no external colour file to worry about which is one of the major plus points for DNG.

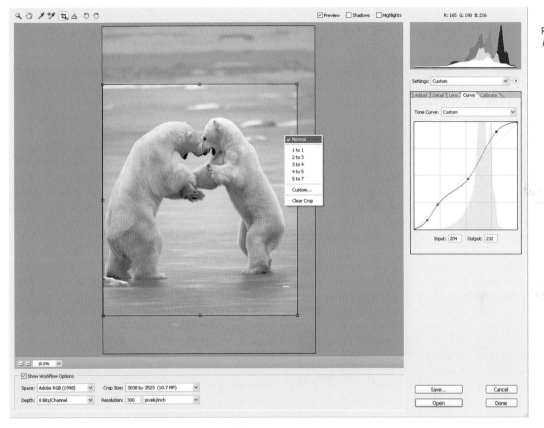

Above *Using the built-in crop function of the RAW converter to focus on the action and remove distractions at the top of the image.*

How do you back up your files?

I actually back up the RAW and colour files to both DVD and two back-to-back external hard drives. Paranoid? You bet, but once you have had a hard disk crash then you learn to be! My hope on writing this book is that one day soon the Adobe DNG open RAW format will be supported by enough RAW software to make its inclusion into all stages of this workflow essential. The benefits to back-up are great as the colour information is stored within the DNG file itself so you only have to back up and retrieve one file. Only time will tell...

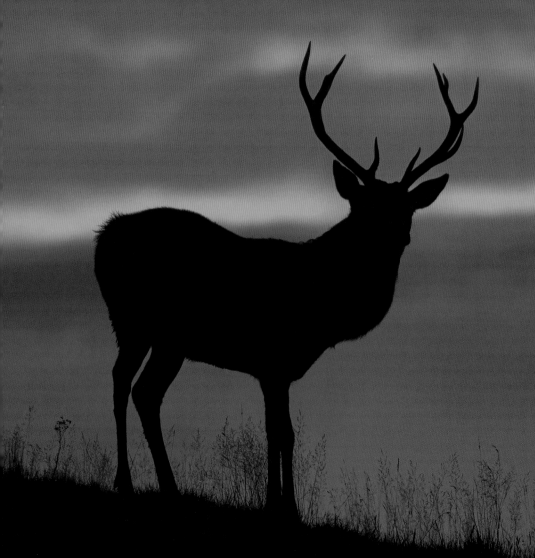

After creating a back-up, the final step is to decide what you want to do with your collection of images. Whether it is making prints, creating slideshows or generating a high-resolution file for post-processing. It is this latter part of the workflow that this chapter will now explore.

The output workflow

RAW software can allow you to perform some amazing changes to a RAW file and for most photographers this will be perfect for their needs. There will be some times, however, when extra post-processing is needed that is currently beyond the capabilities of most RAW software; examples of this includes advanced dust-spot removal, localized corrections whether to colour or noise and more sophisticated black & white conversion. Specific software applications are available for all of these needs and this chapter will provide an insight into some of the options and their usage; it is not meant to be a comprehensive guide, just a starting point.

So now you have a collection of colour-corrected RAW files, all looking great and ready to make their way in the world. Some are destined as prints for friends and family, or to sell via the web, some will be high-resolution files for post-processing in Photoshop while others will be used for lightboxes and emailing or sending for stock. Whatever their destination, most will require conversion into a more widely readable file format such as TIFF or JPEG, as the RAW format to most people outside of the photography world is unviewable and undesirable, although the new version of Windows Vista promises to put this right to a certain extent. This conversion is handled by the RAW software, usually in the form of a batch export dialogue, and for many this has always seemed the obvious final route for their RAWs. Many photographers just convert all their RAW files into high-resolution files (usually TIFFs) and then

wonder why their workstation runs out of space and slows down. The problem is one of size: for example, a RAW file from a 16-megapixel camera takes up about 15MB, while an 8-bit TIFF converted from such a file is around 48MB! That means that just 20 TIFFs can take up about 1GB of space, you can see how quickly a problem can occur, and with digital cameras being given ever-higher resolutions resulting in even bigger output files, it can only get worse.

The solution is simple – think carefully about what you want to do with your RAW files and how you are going to use them before conversion. Once you have decided, here are a few different workflows to help you on your way.

Direct RAW printing workflow

At the time of writing it is becoming possible to print directly from a RAW file without the need (as previously) to convert to a high-resolution file first. Put in plain English, you can apply your corrections to your RAWs then, provided you are happy with the corrections and do not need to do anything else, you can print directly from within the RAW workflow software. This saves a lot of disk space as you do not need the high-resolution file to be generated for the print, which can only be a good thing.

The only real issue to be aware of is that to get an accurate print you will need to generate a profile that is specific to your printer and attach it to the file before

printing. A lesser issue is the ever-present irritation of sensor dust spots; it goes without saying that if you have a bad dust spot then you will have to remove it before printing; this would have usually meant the end of direct RAW printing but several RAW software tools now have a basic dust-spot cleaning facility. It is not as sophisticated as those in Photoshop but for most spots it will do an acceptable job. Remember, the best way to remove spots is to avoid them in the first place.

Proofing workflow

This is a workflow that was invented originally for the pro wedding photographer community but it is great for amateurs too. Wedding photographers send out low-resolution proofs (basically small JPEGs) to their customers. A customer then orders the print that he or she wants and the photographer either creates a high-resolution version of that image for printing or uses the 'direct RAW printing workflow' above; thereby

saving a lot of time and effort. This is a great workflow that works because the low-resolution proof image is a JPEG (usually a medium quality of around '8') which measures 1024 x 768 pixels, the exact screen size of most people's monitors. This means that the proof can be viewed full screen, but is such low quality that it cannot be reproduced or printed much bigger than a postage stamp. The real beauty is that it can be created within the RAW software itself, either by specifying an output size of 1024 x 768 for a JPEG or by using a custom proofing application that does it all for you. Brilliant and so easy, here are some applications:

Below *The integrated printing dialogue in Adobe Photoshop Lightroom allows you to print straight from your corrected RAWs. Note that the image is being tagged with a printer profile that has been generated previously by EyeOne software; this is to ensure that the colour of the final print matches what is seen on the screen.*

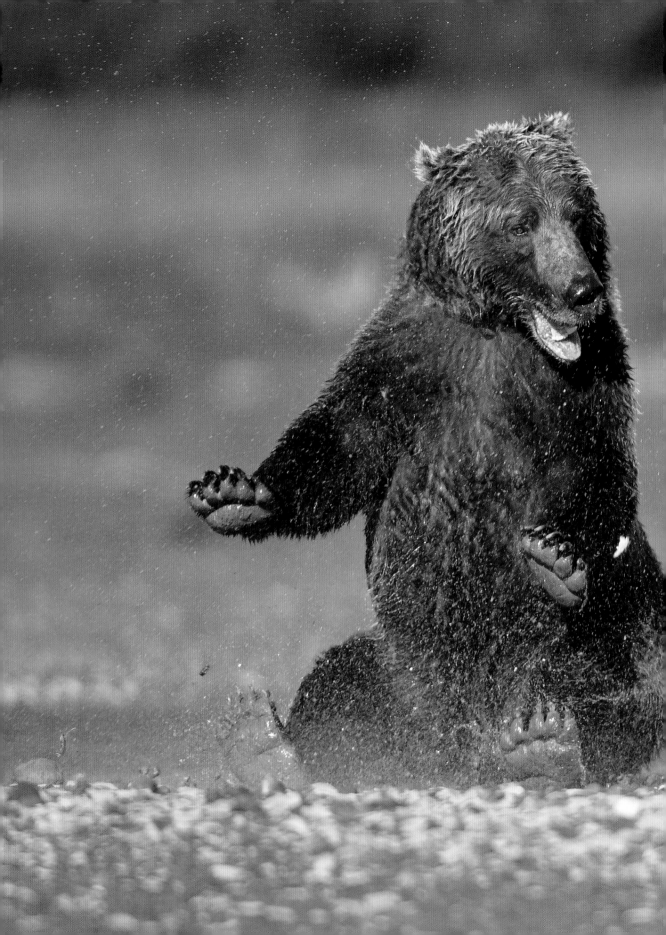

Previous page Grizzly bear fighting over salmon in Alaska. If you want to output large images then the high-res workflow is the way to go.

Clients Professional photographers use this workflow to send clients low-res images quickly and on time, without having to spend ages correcting the high-res files. When the client chooses what they want, only the high-res files for those images are processed. This saves enormous amounts of time and not to mention workstation space. It is great for agency submissions too.

Slideshows It is also perfect for slideshows as there is no need to create a high-resolution file as a monitor can only display one to its maximum resolution – usually 1024 x 768. Anything bigger is a waste.

Email Again this is perfect if you want to email images for review or to friends and family, as the size is usually around 150KB. They will still see it full screen and won't know the difference between a 150KB file and a 20MB one, until they try to print it of course!

High-res workflow

Of course there will be times when you need to create a high-resolution file, perhaps for a client or as part of your own workflow. Usually it is used to perform some extensive post-processing in Photoshop, such as introducing layers or selective noise removal. The creation of high-resolution files is standard within all RAW software as a batch export function, all you need to do is to specify an output directory to store the file and set a few options:

Format Usually a choice of JPEG, TIFF or DNG. If you need a high-res file to work on in a program like Photoshop then it is always best to choose TIFF as you will get absolutely the best-quality output. Although JPEGs are visually lossless there is some compression which might increase noise in the shadows as well as increasing the effect of banding. So unless your chosen

software can only output a JPEG (for example Picasa2 where you will specify a maximum quality file which is visually lossless) always choose TIFF.

Channel size You will get asked if you want to output at 8 or 16 bits per channel. The simple rule is that if you intend to post-process the image and perform some more colour correction then output as a 16-bit file, otherwise just stick to 8. To be honest it is safer to just output as a 16-bit file in case you decide to perform some more corrections, although this is considerably larger than an 8-bit image it can easily be converted back in Photoshop when you have finished.

Interpolation/output size Some RAW software offers you the chance to increase the default dimensions of your image to create a bigger file. This is called interpolation and is primarily used for agency submission requirements or to create a bigger print (perhaps after cropping). For a lot of photographers having this function within the RAW software is a good solution as you will typically only want

PRO Tip

This is the workflow that I use for my professional life. All agents are first sent proofs directly from the best of the best RAWs, if they then decide that they want a high-resolution file I will generate it directly from the RAW. Clients who request images from our downloadable website are sent 1024 x 768 files, usually referred to as 'comping' images, as they can see image quality without being given a usable file. Finally, if any of you have ever come to one of my theatre slideshows, then those images you see projected onto a huge screen are all low-res proofs, 1024 x 768 and all are less than 150KB as there is no need to try to project full-size images.

Left *A typical export dialogue box showing that the image is going to be converted as a 16-bit 300dpi TIFF that will be opened directly into Photoshop for post-processing.*

to step up 100% in size; for instance, from an A4 print to an A3 one. When you interpolate like this, just remember that interpolation works by putting in extra pixels and estimating what tones they should be. It does this by using complex algorithms and comparing the colours of all the neighbouring pixels. Therefore if you want to interpolate using the RAW software, it is suggested that you apply a little bit more sharpening before conversion so as to take this into account. The control over this process given by the RAW software is limited to basically just specifying the size, which as we have said works for small expansions of 100%. If you want to get a little more control, perhaps for a much larger expansion, then the best option is to convert your RAW file into a high-resolution TIFF at the default size (and with the minimum of sharpening). You can then open it in Photoshop and either use Photoshop's bicubic interpolation or an external plug-in to perform the interpolation.

Colour space A complex subject, colour space relates to the pallette of colours that are available when using a particular device, for example, a camera, a monitor or a printer. For most people, it is best if you keep it simple and choose sRGB if you are going to make prints at home or use your images on the web or in a slideshow. Otherwise choose Adobe 1998, especially if you are sending images to clients.

Metadata This controls whether all the metadata (shooting parameters, exposure details, keywords, descriptions, captions and so on) are passed to the high-resolution file or not. Choose yes as you can never have too much metadata! This will allow you to use the embedded metadata during the cataloging process which will be covered in chapter 6.

Conversion is automatic and generally pretty quick – on average 20 seconds for an 8-megapixel RAW file.

Post-processing software

There are many different software programs for editing images. These range from the simple ones that allow basic controls of exposure and saturation (with a few gimmicks like red-eye removal often thrown in) to the incredibly complex and powerful applications that are commonly used in the professional photographic

industry. At the top of the tree is Adobe Photoshop and this is the king of all post-processing software, with, of course, the price tag to match. It can do everything that you need, but for many users it will be a case of using a sledgehammer to crack a nut, especially if you just want to remove a few dust spots. The main alternatives out there are the cut-down version Adobe Photoshop Elements and Corel's Paint Shop Pro, there are also the various software programs that come with cameras, or are installed as part of an operating system's software suite.

Plug-ins

These are mini-applications that run inside Photoshop and which can perform some incredibly useful functions such as masking, interpolation, black & white conversion, sharpening and noise supression. Photoshop generally offers its own options for many of these functions, but some plug-ins offer better performance or are easier to use.

To manipulate or not?

Once a RAW file has been converted into a high-resolution TIFF and opened in a powerful post-processing application, virtually anything can be done to it, the limit is your imagination, and to a certain degree your ethics.

PRO Tip

If I can give you one piece of advice for post-processing it is this: get Photoshop. Yes it is expensive, but so is new camera equipment and that is exactly what Photoshop is. Other software might be cheaper, but Photoshop does the job very well. In addition, many applications are designed to act as plug-ins for Photoshop and will not work with other software.

Left *A simple image that was retouched to remove some unsightly droppings just in front of the penguins.*

The issue of making changes to digital images is one that always stirs up a heated debate. The cause of the problem is that several images can easily be combined to 'retell' the story in the original image; usually this is done to make a more compelling image, often for financial gain. Obviously in the case of fine-art photography this can be argued as being the norm, as it is the impact of the image that is important; but reportage, news and often wildlife photography, these changes are frowned on.

Let us consider the differences between the two schools of thought and it will be up to you to decide on your personal position.

Retouching

This is generally accepted to be the case where the photographer changes the appearance of certain elements of the picture (such as darkening a sky for more impact, or adding more saturation and so on) while keeping the original elements that make up the picture intact. In other words the picture will tell the same story, it just tells it better. This extends, of course, to removing a distracting figure from the background, and just about any change that improves the overall picture without making any false claims about its content. For example, this can apply to landscape photographers who sometimes combine two images of identical composition, but with different exposures in order to get a wider dynamic range. For most this still falls under the umbrella of retouching, as the story of the original image remains unchanged, it has just been improved because either the photographer or the camera could

Below *This yellow land crab showing its mouthparts was shot on Ascension Island. The basic post-processing work that was carried out falls under the banner of retouching rather than manipulation.*

not record the scene without any imperfections. Retouching is accepted by all but the most draconian of photographers as being perfectly fine, and in fact it has been going on in the professional publishing industry for as long as anyone can care to remember.

Manipulation

This involves fundamental changes to the image, such as combining several images to make a new image, which may or may not tell the same story as the original image. It has always been a thorny subject as some photographers do it to create a better impression of their work or to create a more saleable image. This is particularly worrying in the area of news and reportage photography, as the public have to trust the media and the images that they are shown. Unfortunately some photographers have started to manipulate their images, 'bending' the truth to compete in this very commercial world. While this is clearly dishonest, manipulation can, however, also be seen as art. In situations where it is the final image that counts and not its veracity, this is accepted by most people, and there is no doubt that some images are manipulated purely for art. I suggest, if you choose to manipulate an image, that you are honest about it and label it as such, this will allow viewers to make up their own minds, knowing how the image was created.

> ## ◎ PRO Tip
>
> I thought long and hard about putting this section in the book, but I knew that many people wanted me to do it. I have manipulated a handful of my images in the past, at the request of clients or agents or in order to make a fine-art print. When I do this I clearly label it as 'Digital Composite Art', so no-one is under the impression that I actually took the image as it appears. We have to remember that photography is an art form where we are all free to express ourselves, but of course we should do so with honesty.

Things to do in idle moments

Let's move on to some ideas for what you can achieve during post-processing. This book is not intended to be a post-processing bible – there are a great many of those available already – so the remainder of this chapter will just list some common post-processing tasks with some practical advice on the main applications that you can use rather than a step-by-step walk-through. How you apply them is up to you.

Dust-spot removal

Cleaning dust spots from processed images is a real chore and can largely be avoided in the first instance by simply adhering to some of the suggestions made earlier. If, nevertheless, you have dust spots that clearly detract from the picture at magnifications of 100% and below, and your RAW software does not support dust-spot removal, then you will need specialized software to remove them. All the main software brands provide dust-removal tools; of course, some are much more sophisticated than others. Photoshop's new 'vanishing brush' tool is so far the best way of removing the usual kind of dust spot that I have seen as it is very quick and efficient to use, for a larger spot or a hair that needs to be removed try using the 'patch' tool. Whichever tool you choose, the following tips should give you the best results:

- Set the brush size to roughly double the size of the spot size.

- Choose a very soft brush, in Photoshop that equates to one with a hardness of about 10%.

- Magnify the image to 100%; any defects that are not visible at this magnification can be ignored.

- Check each result carefully to see that it is seamless as some removals can leave traces – the tools are good, but not perfect. If in doubt, then use the 'undo' function and correct that spot again.

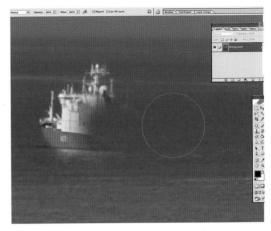

Object removal

Objects such as distracting background highlights or an out-of-focus foreground element such as grass can really distract from a great image. Removing them is usually a simple task, especially for the background element, but care should be taken as it can be hard to remove them without leaving a trace. This is particularly noticeable when attempting to remove objects from across a face; if you leave traces behind and they are seen then this can generate mistrust that you have done something that borders on manipulation, when all you have done is some basic retouching. For complex removals, it is best to use a combination of removal tools; just build up the removal in stages, zooming in and out to see how effective it is each time.

Above *An amazing sight of 200,000 king penguins in a colony, which a client wanted altered to remove the ship.*

Above right *Using the Photoshop Rubber Stamp tool the Royal Navy's HMS Endurance is being scrubbed out.*

Opposite page *The ship has been removed from the final image, although I prefer the one with the ship included as it shows scale and context.*

 PRO Tip

There is always a temptation to try to remove all distracting elements from a picture and make it 'perfect'. However, we live in an imperfect world and elements that you might at first consider distracting may actually add to the image.
For example, a lot of my subjects are shy and wary and stare at me through tall grass; I could remove it, but it might spoil the story. Take a long look at your image and decide what you are showing.

Left *Images with a wide range of tones included can require localized corrections, to prevent a correction that improves one area detracting from another. This is best done using Layers in Photoshop.*

Fixing local colour and brightness

By now you will have realized that the digital camera can't get it perfect every time, and that almost all RAW files will need a little tweaking here and there. This is particularly relevant when dealing with skies, or in fact any image that has a large dynamic range (in other words a spread from very dark to very light tones). These images often require a little post-processing as they will need localized changes, which affect one small area, but do not affect the image as a whole; for example, darkening a sky that has been overexposed due to the tones of the foreground. Such processes can be increasingly completed in the RAW software, but these changes are generally global.

The subject of applying selective, local corrections could take up a whole book and as space is limited, it is the best plan to point you in the right direction – Photoshop's adjustment layers. These allow incredibly powerful corrections to be applied to selected parts of the image using a painting technique to mask the areas you don't want to alter, you can then adjust how the layers blend together to modify the effect.

Black & white conversion

Black & white photography has undergone a great resurgence since the birth of the digital camera, and it is great to see this medium being appreciated again. The previous chapter showed how you could use RAW software to convert colour images into black & white; but for most decent art prints you will need a specialized black & white application to finish this off. Photoshop CS3 has a very good built-in black & white conversion tool, or you can use the channel-mixer or lab colour-conversion techniques. There are also many plug-ins which are mini darkrooms and allow you to add all kinds of filter effects without knowing more than how to move a slider. Any of these will allow you to produce a black & white print of which you can be proud.

Noise suppression

If you have a high-res file that needs some intelligent noise suppression, then there are plenty of applications to help you, both in the form of stand-alone products and Photoshop plug-ins. At first, these applications can seem daunting as they have a multitude of controls, but usually the default option will be a great starting point, and is often all that you need. It pays to remember that noise suppression, no matter how intelligent, will remove detail from your image and can cause it to look extremely lifeless.

There seems to be an obsession about removing noise, yet in many cases the noise does not need to be removed since it does not detract from the image.

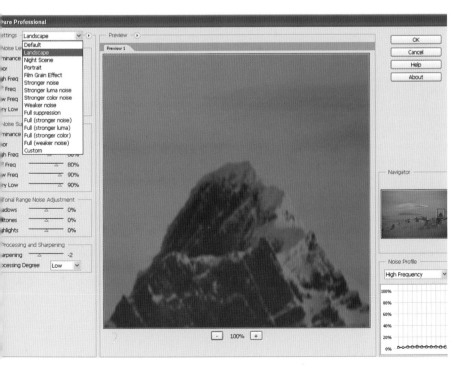

Above left *An example of a black & white plug-in that is being used in Photoshop to create a piece of monochrome art.*

Left *A very noisy image that was taken 30 minutes after sunset is being processed by a stand-alone application to remove the noise.*

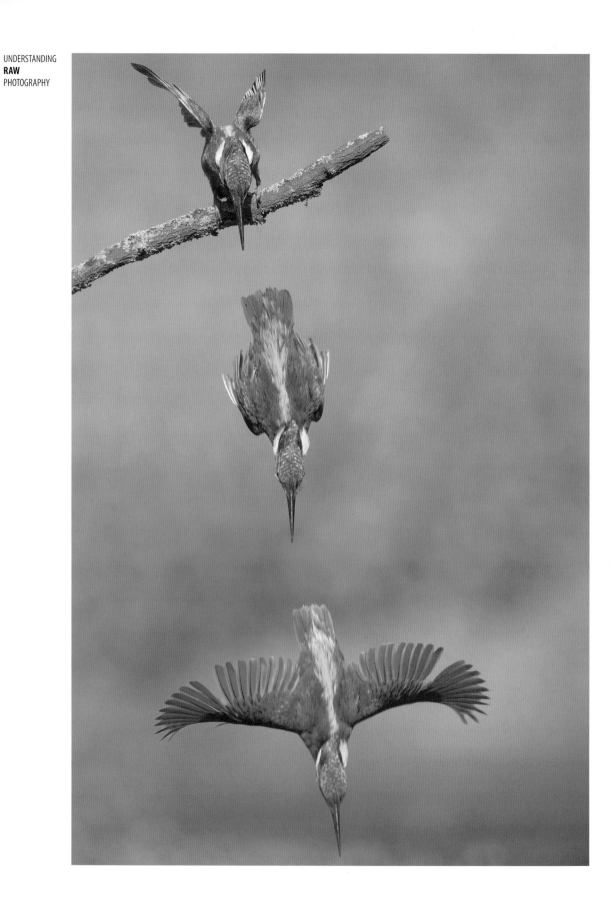

More often noise will only manifest itself in the dark, shadowy areas of the image and therefore only localized noise suppression will be needed for these areas, which will leave the main detail in the image alone. The most difficult part of removing noise locally is selecting the area to remove it from, the simplest Photoshop tool to use is 'quick mask', which allows you to use a painting technique to select the area that you want; as you are only removing noise it is not important that you are totally exact.

If in doubt then simply use Photoshop's layers to add an extra level of control. Duplicate the existing layer, apply the noise reduction to the top layer and use the opacity to blend the noise reduction in so that does exactly what you want it to.

Interpolation

Digital cameras have a fixed maximum output file size (which is governed by the number of megapixels on the sensor) and often you will want to make a larger file than this allows. This may be to allow a slightly larger print, or perhaps to match a stock agency's submission requirements (often around 50MB). Either way you will need a way of increasing the default size of your file, and this is called interpolation.

There are countless stand-alone applications and plug-ins to do this, all with roughly the same features and claims about their performance. Just remember that if you increase by more than 100% from the default size, you will see some image degradation. To be honest Photoshop's own bicubic interpolation does a pretty decent job for enlargements up to 100%.

Left *A composite image that was put together from three separate images to show how a kingfisher angles its wings during the dive. This kind of image is educational and bears the IPTC caption that it is a digital composite. This kind of image requires the use of layers as mentioned on page 112.*

Below *This high-res file was only 20in (50cm) along the longest side and was needed by a client to be 60in (150cm) for an exhibition display. Here a specialized plug-in is being used to interpolate the image up to the new size, it is literally as easy as plugging in the new size and clicking OK!*

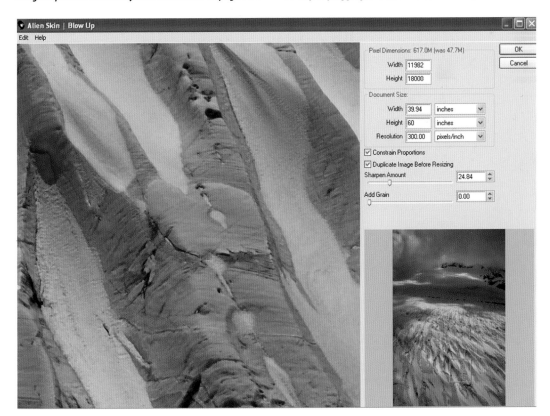

Digital asset management

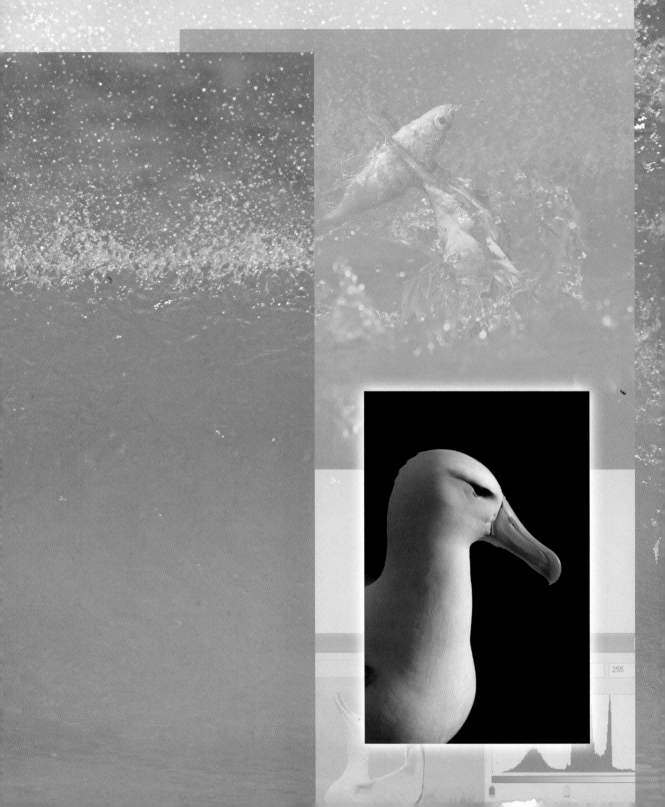

So we have reached the final stage of the workflow, now is the time when to manage the files that you have carefully selected, edited and corrected. This is generally called digital asset management, and is known widely as DAM. In fact DAM has now come so far that it is possible not only to manage your files, but to manage your entire workflow visually using some excellent applications.

Management systems

For some photographers, the end of the workflow will be the natural time to catalogue everything, others will use Digital Asset Management to control the workflow from start to finish. The purpose of this chapter is to introduce you to the concepts of DAM and some of the advantages and disadvantages of adding it at various stages of the workflow.

So you might ask why you need to bother with DAM? The simple answer is that a good DAM system will help you find and manage your pictures much more easily, whether they are TIFFs, RAWs (including DNG) or JPEGs. You will have a central reference point for all of your work, so that you can easily find out metadata for a particular image. Each image or group of images can be keyworded for quick reference, catalogued in groups or collections and organized so that you can find them easily. The best DAM systems also have lots of mini applications within them for creating web galleries, sending to online print services and even creating 'blog' entries.

There are some good reasons for having a good, integrated DAM system while the only real negative is the extra time that you will have to take in adding DAM to your workflow; however, the benefits to your photography far outweigh this minor cost. Of course, you may decide that you do not need a DAM system at all, but in my opinion this usually turns out to be a huge mistake.

Right *The boundaries between DAM applications and RAW converters are reducing all the time and now most DAM applications are able to perform quite sophisticated colour correction and conversion. Here you can see a basic levels change being performed, something which has been discussed in earlier chapters. Of course the tools provided are not as sophisticated as in products such as Lightroom and Aperture but they will be perfectly sufficient for a lot of photographers. If you need to make more complex corrections then you can either open the RAW file in a more specialized application or make the minimum of changes and then open the generated TIFF into Photoshop. The advantages to your organization of doing all this from one place are obvious.*

The software

This chapter will look at some simple DAM workflows: one for the photographer who wants to just keep it simple and have it as the final stage of the workflow and one for the photographer who wants to fully integrate DAM into all stages of his or her workflow. The first consideration though is the DAM software itself. There are several software options for digital asset management:

Operating system

The cheapest way of implementing DAM is to use the existing Windows or Mac operating system that you have. The operating system can be configured to display files as thumbnails so you can at least have a visual reference of them, but this can be painstakingly slow if you are looking at a number of high-resolution files. So while it may seem like a good short cut, it is generally not! The one proviso is that, at the time of writing, no-one had seen Microsoft's new Vista operating system. This promises far better functionality for photographers than Windows XP ever did, however, only time will tell if it offers a decent DAM solution.

Below *One of the great things about DAM applications is that they are able to integrate software from other vendors and they recognize that a photographer may have many applications that they want to use in their workflow. These applications are called helper applications.*

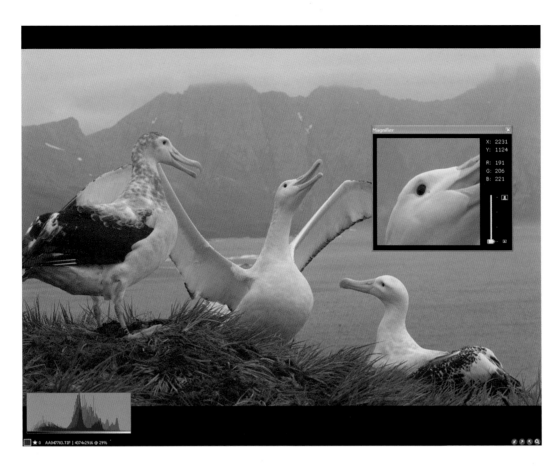

File browsers

There are some remarkably good file browsers on the market, such as Adobe Bridge (a part of Adobe Photoshop), Photo Mechanic and BreezeBrowser. These browsers allow a real-time view of the contents of a particular directory, but as they read the actual files, they slow down if a directory contains large files. They do, however, offer some great functions including the ability to view metadata, prioritize images, tag them and lots more extras such as website slideshow creation. Many photographers use this method alone for controlling their workflow, but they are not true DAM applications.

Above *You can see here how iView is displaying a RAW file full screen, along with the histogram and also a magnifier to allow close inspection to check focus.*

RAW software

Some advanced RAW software such as Apple's Aperture and Adobe's Photoshop Lightroom programs provide DAM capabilities within the actual software itself. These are amazing pieces of software for both the professional and serious amateur photographer, and they allow you to carry out each stage of this workflow within the same application, thus saving time, money and complexity. Other RAW software offers fewer functions, however, and concentrates solely on the conversion part of the process.

Custom DAM applications

These programs are designed specifically for DAM and have all the features that you will ever need. A major feature of them is that they are location independent, in other words they can have files from a number of different directories or locations displayed in the same place. They are fast as they rely on a preview image which is taken when you add files to the catalogue; since these DAM applications do not have to refer back to the directory (apart from an initial scan) each time the response is instant. These applications are designed to be easy to use, with simple menus to guide even the most unfamiliar user and no need to know any kind of programming language (unless you are doing some pretty complex and specialized stuff). Most DAM applications also link to external programs, such as RAW software and Photoshop, so it is possible to use them as a central point of control for your workflow. Some even offer basic correction techniques for RAW files, which may be all that some photographers ever need.

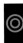

PRO Tip

There are undoubtedly two kings of the DAM world. Picasa is an amazing free DAM application from Google and provides great functionality, and for a lot of photographers it will be all that they will ever need. There is always cynicism about free software, but trust me that Picasa is a great piece of free software. Microsoft's Expression Media is a new version of iView Media Pro and is available for both Macs and Windows-based PCs. It provides all of the functionality that even the most demanding photographer will need, including DNG support, basic RAW corrections and a multitude of mini applications. I recommend downloading them both (there is a free trial version of Expression Media) and seeing how you get on, just make sure you take time to read the manuals as DAM applications can take a little getting used to.

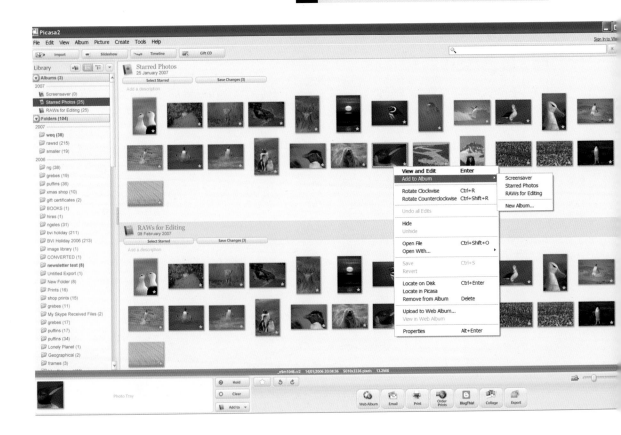

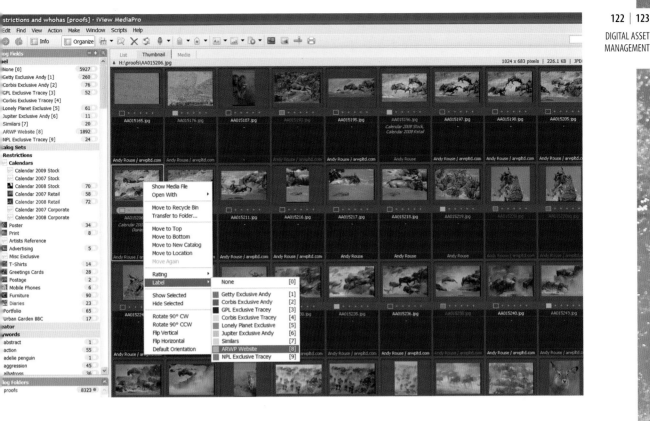

DNG – made for DAM

Throughout this book you will have seen many different reasons for adopting the Adobe DNG format, but here is one of the most compelling. It has already been mentioned that DNG is a well-documented open standard, in plain English this means that many applications can use its data in the same way. So fields that are stored in the DNG file, such as XMP metadata containing tag ratings and keywords for example, are available to all applications that support DNG. This means that DNG can be used to integrate applications as never before; for example, the ratings and keywords that are set inside RAW software or an image browser that supports DNG can be read and displayed by a DNG-friendly DAM application.

Above *As already mentioned in the text we use iView to control our professional imaging library so we can assign any rights restrictions against particular images.*

There is another great reason to use a DNG workflow with a DAM application. A DNG file contains the colour corrections that you have made during that stage of the workflow, and following on from the points made above these corrections are stored in a standard format. This means that a DNG-friendly DAM application can read these corrections and display the colour-corrected DNG file, rather than just the original non-corrected file which is the case with the pure RAW format. This is a great feature of DNG as there is nothing worse than looking at the original file, when you have already improved it hugely.

Left *The free Picasa2 program from Google is a simple DAM application that will get you started into the DAM world. It has some great catalogue functions, can launch other applications and perform basic modifications to RAW files.*

DAM and RAW workflow

Hopefully you can see the benefits of a DAM application to your workflow; basically it introduces a visual element that makes it much easy to manage and control your images. Most DAM applications are stand-alone programs – independent pieces of software that are just designed to look at the files stored on your computer. The exceptions of course are Lightroom and Aperture, as these include a wider array of functions, but they still work in a similar way.

Organizing your DAM system

Before starting to use the DAM application in anger you need to sit back and think how you are going to organize it. Usually there is one global 'show me everything' catalogue view or collection, followed by lots of sub-views that show subsets of images. As an example you could have the main catalogue with all of your animal pictures and then individual collections for birds, mammals, reptiles and so on, which is then subdivided further into individual species. Alternatively, you could structure the sub-views based on the location and the date they were shot (which is a very popular option). Keywords are another great tool that you can use; just make sure you keep them simple and generic such as 'family' or 'holiday' or 'spain' so that they are not too specific to be useful. When you import files into the DAM application you will be ask to specify all these things and they will all be assigned during the importing process, saving you a lot of time and effort. Every photographer has different requirements and there is no right or wrong way to do it, it can be as simple (which I recommend) or as complex as you want to make it.

What follows are two simple workflows that contain a DAM application to manage the files, one is very simple and one is fully integrated to show how a DAM application could control a workflow.

Simple DAM workflow

This DAM workflow bolts onto the end of your RAW workflow and can be thought of as the final step as all you are interested in is cataloguing the end results, in other words the high-resolution files. 'What about the RAW files?' you might ask. Well, if you have processed them correctly then it is unlikely that you will need to refer to them again; as part of the workflow they will be backed up to CD/DVD or external storage and therefore you will know where they are if you need them. But it seems senseless to clog up your DAM system with all of these RAW files, as we are just interested in the end results – either small JPEG proofs (proofing workflow) or high-res files (high-res workflow) as these will be the files that you may need to work on (during post-processing) or to distribute in one form or another. Although this is an incredibly simple workflow, the main steps are outlined below for the user who is new to DAM.

Complete the RAW workflow as shown throughout this book. At the final stage you should either have a directory of low-res proof JPEGs (to be used for slideshows, web galleries and similar functions) or a directory of high-res JPEGs or TIFFs (or even both). These are the files that need to be added to the DAM system.

To get the files inside the DAM application you will need to import them in one of two ways: manually – by specifying the location of the files and any extra information like common keywords that you are prompted to include; or automatically – some DAM applications are sophisticated enough to monitor a specified directory for any new files. So as the final stage of your post-processing workflow you can ensure that you the save the file to this monitored directory, at which point it will be catalogued automatically by the DAM application. This is a great way of ensuring that you do not forget to catalogue your files, but it does assume that you save all of your high-res files to the

same directory and never move them. It also assumes that you will remember to catalogue them and add the keywords and other details at a later date.

If your DAM application supports XMP metadata then any ratings or keywords that you may have assigned earlier in the workflow should be picked up and used by the DAM application itself. Provided that you specified to keep the EXIF information during the creation of your high-res or proof images then you also should have all of the EXIF metadata available too.

Once your files are catalogued inside the DAM application you can then start to organize them as you want and use the DAM application to move them around (so it does not lose their locations). In addition, most DAM applications offer support for right-clicking the mouse, which usually gives many options and usually one very useful one is to open that image into an external application such as Photoshop. So you can open the image, perform some extra processing, save it and the DAM application will refer to the saved image.

Using a DAM system in this way is the traditional way of using it within a RAW workflow and there are no downsides apart from the cost of additional software (which in any case will not be an issue if you use the free Google Picasa2). However, a more elegant solution is to achieve a fully integrated RAW workflow, one where you can use an umbrella piece of software to manage each step of the RAW workflow and to keep control of it.

Integrated DAM workflow

Some photographers fully integrate their DAM application and use it at all stages of the RAW workflow. This was always used by professional photographers who needed to manage a lot of images and could take the time to spend actually doing it. Now that a new breed of fully integrated DAM applications is available (such as Picasa2 and Expression Media) this process has become easier to achieve for a wider range of photographers. The main reason for doing is that you can now use the DAM application as a central point for controlling the entire RAW workflow. In other words you can manage the workflow from a visual perspective rather than the traditional one of locating files and moving them between directories using the operating

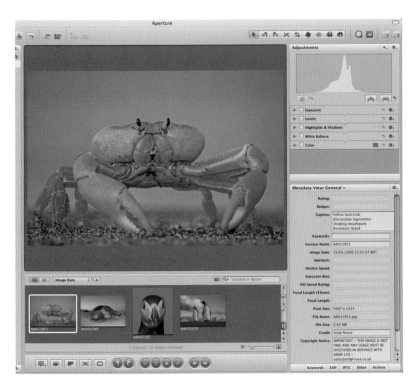

Left *Metadata is an important part of the DAM workflow, it provides another set of variables with which you can organize your images, for instance, via appropriate keywords.*

system. This is a great bonus of using a good DAM application; it is also easy to customize, easy to manage, as well as being easy to keep track of the workflow and the status of your RAWs through it.

The DAM application acts effectively as a central 'launching' point for a workflow consisting of separate elements; if it cannot perform a particular function, say, for example, RAW correction, then it is able to launch software that can. Of course some DAM applications can now perform some very basic forms of RAW correction, although these are basic they are probably sufficient for many photographers. As an example, consider the following as a starting point to show you how a fully integrated DAM workflow might work using the workflow so far outlined in this book. Although based loosely on Microsoft's Expression Media, it can easily be adapted for any DAM software as it is just showing the outline of the workflow:

Download and catalogue RAWs

Management of the workflow begins right at the beginning of chapter 3; most DAM applications can now help you manage the process of downloading your RAW files onto the workstation. Along the way you can add keywords, shooting descriptions and cataloguing options

that organize your collection without actually doing anything more than clicking a button. Of course you might prefer to use your own download software for this and in this case the DAM application updates its catalogue (either manually or automatically) once the RAW files are on the workstation. Whichever method of the workflow you choose, just remember that the RAW files you are managing are unedited and need to be kept away from any other RAW files in order to avoid confusion; they will be downloaded to a single directory and within the DAM application most photographers create a sub-catalogue containing the date or shoot name to identify the files. This name will be used to manage the files throughout the workflow and they will remain in the same directory throughout, their numbers being reduced until eventually the catalogue contains only your 'best of the best' RAW images. Additionally you can easily add some kind of unique tag or colour to this group of RAWs to indicate that they are not edited to make sure they stand out from any other RAWs in the DAM application. Most DAM applications support the majority of common

Below *DAM applications like iView all have a download or import function for new images, as do Adobe Lightroom and Apple Aperture.*

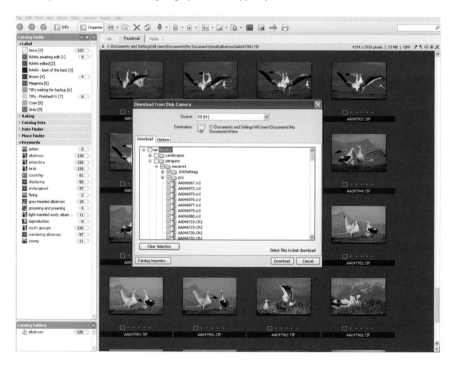

RAW file formats so you should be able to see the RAW thumbnails in the catalogue, better still if you convert them into the Adobe DNG format first.

Editing

The editing workflow in this book adopts a 'multi-pass' strategy and the DAM application can be easily integrated within this. Remember the whole point of the editing workflow in chapter 3 was to take an entire collection of freshly downloaded unedited RAW files and edit them down aggressively until only the best of the best remain. The starting point of the DAM workflow will always be the catalogue created above as this contains all of the new unedited RAWs:

Slideshow The first step of the editing workflow is to remove the rubbish (see page 60) and this can usually be achieved without leaving the DAM application, as most have a basic slideshow function. Each RAW file in the directory can be displayed, usually in filmstrip mode so you can see the next few shots in

Below *Using a colour label is a good way of visually separating RAWs without changing their location. This is great if you want to do everything from one application.*

the sequence, and if necessary the RAW file can be deleted. Of course you may prefer to use your RAW software or image browser for this process, and if this is the case, then just launch it and edit the directory in which the RAW files are kept. When you have finished, the result will be the same as if you used the DAM method, the catalogue now though will only show the RAW files that are left (although you may have to refresh it first).

Similars At the present time DAM applications do not have a full-screen preview with a zoom capacity that can be used to tile similar images next to each other, when they do you can use the DAM for this, in the meantime just launch your image browser or RAW software application to perform this stage of the edit. Again the end result will be the same, the DAM application (maybe after refreshing it) will show only the few RAWs that are left in the directory, these are your edited RAWs.

Best of the best This part of the workflow is the one that sees the biggest changes caused by using a DAM application as this function will be performed by the DAM application and not the RAW software as before. Remember although you are going to keep the

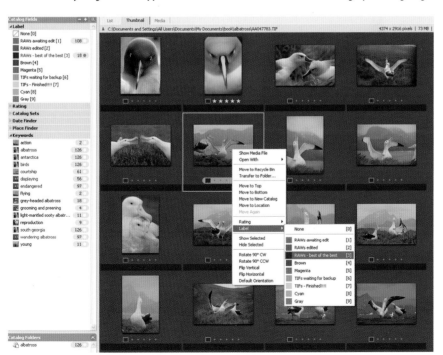

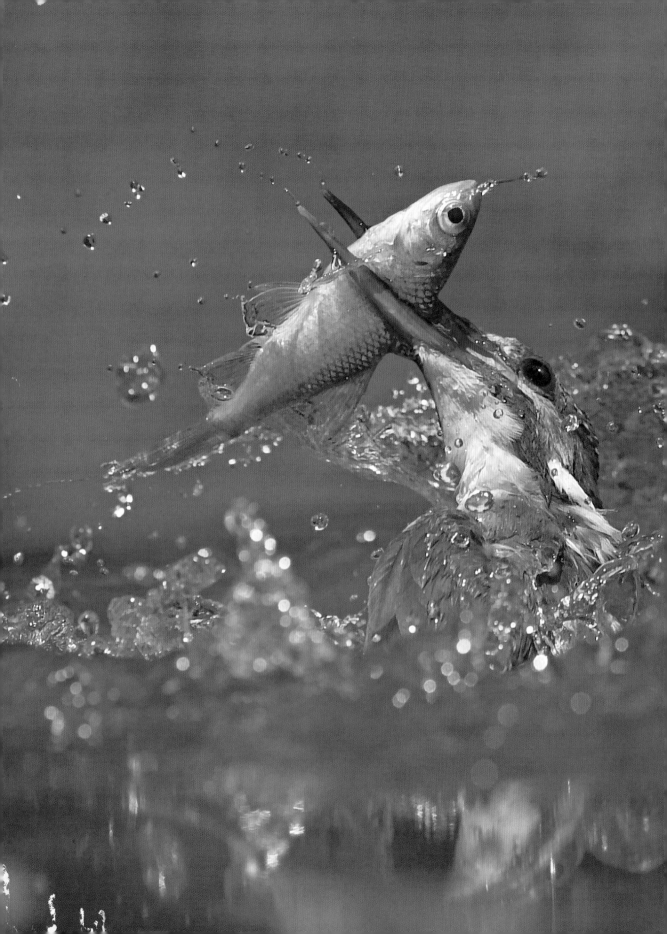

Left *In order to streamline your workflow you need to be realistic and concentrate on working with the files that are the best of the best.*

Below *A vital part of any workflow is the back-up stage and most DAM applications now have the ability to make a CD / DVD. So do all-in-one applications like Lightroom and Aperture; putting it all under one roof saves time and reduces the chance of forgetting to back-up something important.*

edited RAW files it is unlikely that you will ever get to process them all, so you have to pick out the best of the best images and identify them for processing. To do this within DAM is easy, all you do is to have a tag or rate them with a colour or similar method that is unique. This will allow you to easily pick out these files from the rest in the edited catalogue, so that they can be given priority for processing at the next stage of the workflow. If you are using DNG files for your workflow then, provided the RAW software, the image browser and your DAM application fully support DNG, you can set the best of the best tags anywhere and the other applications will be able to display them accordingly.

Back-up If you want to take a back-up at this stage then the DAM application will usually provide an integrated facility to do this without having to go anywhere else. This can be either to CD/DVD or an external drive.

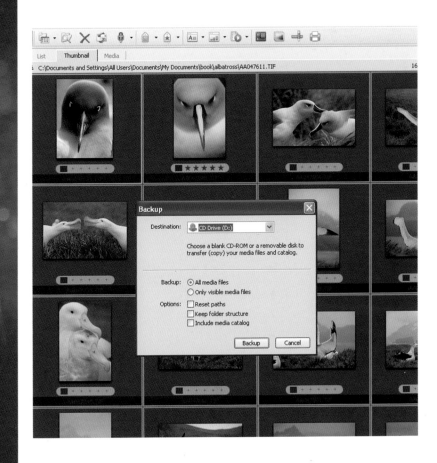

Renaming At the time of writing, the task of renaming your edited RAWs is still the domain of the RAW software or image browser. If this changes then great, more power to the DAM application, if not then just use which software you want as before (link to chapter 3). The end result will be the same as you are still using the same directory as before – the DAM application will show the renamed RAW files.

Correction Increasingly, some DAM applications are providing the capability to perform colour and formatting changes to your RAW files. At the moment these are limited to the basics – such as exposure, white balance, saturation and fill light – but for most photographers this will be all that they are interested in. Some DAM applications though are starting to provide more sophisticated tools including variations to show different varieties of the image such as black & white and sepia, which can save a lot of time and hassle. Of course many photographers will still want to perform corrections within their favourite RAW software and in this case it is easy to launch this from within the DAM application. You can then process your RAW images as described in chapter 4 and if you are working in DNG, the resulting corrections will be reflected in RAWs when viewed from the DAM application.

Output workflow
The end of chapter 4 described three very different output workflows depending on how you wanted to use your images:

High-res If you choose to turn your RAW image into a high-res file, then you will most likely want to get your DAM application to catalogue it. Just use the same techniques described earlier on in this chapter.

Left If you want to get the very best from your files then you will probably need to convert them into a high-res TIFF for further work in a program such as Photoshop, a high-res image can still, however, be integrated into your DAM workflow.

Proofing The proofing workflow outputs screen size JPEGs instead of high-res files, which can be then used for sending to clients or for building slideshows or web galleries. Again you will want to catalogue these as they will be your output files that you will most commonly use, hence either of the methods outlined above will work.

Direct RAW printing This will be under the control of the RAW software and so will have little effect on the DAM application. You might want to use the DAM application however to store away facts about the print such as the size of the edition etc.

Post-processing For some RAW files, there will always be the need for post-processing in applications like Photoshop. This is simple to achieve from the DAM application, and means you can work with one image at a time using the DAM application as the central 'launcher'. For most amateur photographers the only reason to use post-processing in a separate piece of software is for dust-spot removal or for adding details to the XMP metadata of the file. The latter can now be achieved within most DAM applications and if the former is added, then there will be little need for most photographers to launch outside of the DAM application itself.

PRO Tip
You will quickly find that your DAM application will become vital to your workflow and you will be lost without it. Therefore back it up! Take a back-up at least once a day to a location away from the workstation – there are plenty of free software applications to manage this for you.

Conclusion

Those photographers reading this book who are new to digital, will wonder what all the fuss is about, to them it will be obvious that a DAM-based workflow is the easiest solution for the RAW workflow. If you are just starting out in digital photography, then you will not have a legacy of digital files behind you, and will also not be set in your ways with your preferences and prejudices. Unfortunately, everyone else will need to think quite hard about how to integrate DAM into their workflow. One thing is for sure though, this is the way forward for the RAW workflow and one which will become progressively more straightforward as time passes.

Above and right *If you want to be able to maximize the quality of your images then the RAW format is the way to go. It offers you unsurpassed flexibility and means that each image that you take with your digital camera is packed full of potential, you don't just have to live with the end result. However, you should always bear in mind that RAW files make digital photography more of a process than it has ever been before. So it is important that you consider each stage of the workflow whenever you are making decisions, even when you are out in the field taking pictures.*

Glossary

Adobe 1998 RGB A wide-gamut colour space that is generally used when printing using a four colour (CMYK) process.

Aliasing The appearance of jagged pixel edges that can be seen within any curves or lines of the image at or around 45 degrees. Anti-aliasing is the process used in Photoshop and other image software that helps to soften the edges of the image to reduce the effect of aliasing.

Algorithm A mathematical equation that gives a solution for a particular problem. In relation to photographic imaging this relates to a set code that will define how values of particular pixels will alter in an image.

Artefacts Imperfections in an image which are generally caused by image manipulation, inherent flaws in the capture process and also by any computer errors which may manifest digitally themselves in the image. These can be exacerbated by compression.

Aspect ratio The ratio of the dimensions of an image (width:height).

Batch conversion Converting a number of files from a RAW format into your chosen format, usually JPEG or TIFF, at the same time.

Bicubic interpolation A method of interpolation whereby new pixel data is created by calculations involving the value of the nearest eight pixels. This method is superior to other forms of interpolation such as bilinear interpolation and nearest neighbour.

Browser Any piece of software that allows you to view you image files, generally in the form of thumbnails and then as full-size previews when selected. Other functions may be included.

Calibration Matching the output of a device to a standard to create consistency, for example, between the colour that you can see on screen and that produced by a printer.

CCD Charge coupled device: a semiconductor which can measure light and is the device which is commonly used in many digital cameras.

Channel Information within the image that falls into a group. This is generally used in reference to colour channels, such as red, green and blue.

Clipping The occurance of image data that falls outside the colour gamut of the device being used or the dynamic range of the sensor. This records as pure black or white, without detail.

CMOS Complementary metal-oxide semi conductor, an alternative to the CCD sensor that is widely used in cameras and computers.

Colour gamut Simply the range of colours able to be reproduced by a device and visible to the naked eye. Also the range of colours available within a particular ICC colour profile.

Colour mode The way in which an image presents the colours and tones that it contains. Not to be confused with ICC colour profiles, colour modes include RGB, CMYK and greyscale.

Colour temperature This is a measure of colour quality which is specified in terms of a Kelvin rating. A low kelvin rating of 5,500 or below renders warm tones while anything over 5,500 kelvins renders cool blue tones. Colour temperature can generally be adjusted during the RAW conversion process, using a slider that will show the effects of the changes via a live preview.

Compression A process where a digital file is made smaller to save storage space. Compression comes in two types: lossy, where the image quality is degraded and lossless, where the original quality of the file is kept intact.

Contrast The transition between highlights and shadows, this can be controlled by a slider during the RAW conversion process.

Conversion This is the process that converts a RAW file into a different format. In the process it makes any changes that have been applied to the RAW file permanently applied to the final file. A number of additional functions such as renaming and keywording can also be carried out at the same time. More than one file can be converted at a time, this is called batch conversion.

Cloning The process of duplicating pixels from one part of an image and placing them onto another part. Often in order to remove distractions.

Cropping The process of reframing an image and sometimes altering the aspect ratio at the same time. Some applications allow you to also interpolate the image during the cropping process.

Curves A tool that controls exposure via the use of a curve that controls the relationship between input values and output values.

Desaturation The most basic way of converting to a black & white image involves simply removing all of the colour saturation using the saturation slider.

Dialogue box A box which allows you to make alterations to various aspects of an image in a program and often view those alterations before finalizing the effect or command.

dpi Dots per inch is a term that is used to represent the resolution of a digital file or print.

Digital negative (DNG) An open RAW format, in other words, one that was not created by a camera manufacturer and which has widely published specifications. This theoretically allows for better conversion, and safeguards the file from becoming an obsolete format.

Driver A piece of software that is designed to control and run a perpheral device from the computer such as a printer.

Dynamic range The range of different brightness levels that can be recorded by a digital sensor.

Edge sharpening Image manipulation performed to create higher contrast edges.

Embedded data Data that is tagged onto a file for future reference, this includes ICC colour profiles and Exif data.

Enhancement Changes applied to the image, brightness, colour or contrast, which are intended to improve its appearance, but not change the overall 'story' that the image tells.

File format The format in which a digital file is stored. Each format has its own qualities, some use compression to make file sizes smaller whilst others, such as use no compression to preserve the integrity of the image. The format of a file will also determine its flexibility and which programs can read it. Note that the term RAW does not refer to one particular format, rather a group of formats with similar properties.

Filter Filters offer a way of applying an alteration to the whole or selectively chosen parts of the image.

Greyscale A monochrome image which is based of 256 tones starting from white and going through a range of grey tones until it reaches black.

Healing brush A more advanced version of the clone tool, which automatically blends source pixels with background pixels to create a more realistic effect, for example when removing dust spots.

High resolution The term high resolution generally refers to those files that are suitable to print, this is typically accepted as being those files with a resolution of 300dpi at the specified size.

Histogram A graph of the spread of pixels tones, showing the number of pixels on the vertical axis and the range of tones on the horizontal axis.

Hue The colour of light as distinct from its saturation and its luminosity. This can be adjusted via a slide in the RAW conversion software.

ICC colour profile International colour consortium profile. A named colour gamut that harnesses various characteristics and has openly available specifications.

Interpolation A method of increasing resolution by inserting new pixels into the image based calculations from existing pixels.

JPEG A file format that was developed by the joint photographic experts group featuring built-in lossy compression. The compression enables otherwise large image files to take up a far smaller amount of space, with variable quality and compression.

JPEG 2000 A newer version of the JPEG file, being more flexible and allowing better quality, creating less visible artefacts.

Kelvin The unit of measurement used to express colour temperature within an image, 5500 kelvins as indicative of normal daylight, below this temperature images become progressively warmer and above this temperature images become progressively more cold. A colour temperature slider is available to apply alterations in most RAW conversion software.

Keyboard short-cut Designated keys in software programs either preset or changeable by the user to run commands at a key stroke. This is in order to ease your workflow.

Layer A floating copy of the original image, or in fact any image, which sits on top of the background image, multiple layers may be opened with different effects applied to each one. They are like virtual sheets of sitting on top of the image. Layers make manipulations far more flexible than they would otherwise be. To preserve layers for future manipulations the image must be saved as a PSD format file.

Layer opacity The opacity or transparency of each layer covering the background image. As the opacity is changed the layers beneath become more or less visible. This can be used to vary an effect that is only applied to one layer.

LCD Liquid crystal display, digital camera screens for reviewing images and accessing menus as well as laptop computer screens are LCD screens.

Levels A simple tool that is based on a histogram, which allows the correlation between input and output values to be adjusted in order to alter the exposure.

Low resolution The term low resolution is generally taken to mean any image that is suitable for display on screen, but not for printing.

Manipulation A term for any alterations made to an image that stretch beyond enhancement and actually change the 'story' that is being told by the image.

Mask A tool that is widely used within Photoshop which allows the user to mask off areas which will be excluded from the various manipulations applied to the image.

Megapixel One million pixels, multiples of which are commonly used to denote the resolution of digital cameras' sensors or of an image; for example, a 10-megapixel camera.

Midtone The middle range of tones in an image that reflect 18% of the light that falls on them.

Monochrome An image made up solely of various tones of grey, or for that matter any other single colour.

Noise The randomly and incorrectly coloured pixels that can afflict a digital image. These are often caused by a high ISO setting or a long exposure. Lightening an image's exposure can make noise more obvious, particularly in the shadows.

Opacity The transparency of an effect that has been applied to an image, or the transparency of one layer that is placed over another, this is controlled by the opacity slider in the layers dialogue box.

Out of gamut A term that relates to colour that can be seen and reproduced in one colour space, but not are not seen or reproduced when taken into another colour space, such inaccessible colours are termed as being 'out of gamut'.

Overexposure Either rendering an image lighter than it should be by allowing too much light to strike the sensor, or the complete loss of highlight information through tones being rendered too bright to be captured with detail by the sensor. The first is correctable, but the second is not.

Palette A menu within the editing mode allowing select changes to the colour and the brightness of an image.

Pixel The smallest part of the image, the building block of the image, stands for picture element.

Pixelation The visibility of individual pixel edges within an image, often caused by excessive enlargement.

Plug-in An accessory file that operates through another program. Typically this will be Photoshop and the plug-in will be incapable of running without independently. Plug-ins perform specific functions such as noise reduction.

Preset While many corrections to RAW files are made using sliders, there are also generally a number of presets that are available. For example, while the white balance can be adjusted by using the colour temperature slider provided, it can also be altered by selecting a white balance preset such as 'daylight', 'tungsten' or 'flash'. The sae is true for other parameters.

RAM Random access memory. A rapid form of memory communication where the computer stores data in order to process functions. Photoshop itself is very dependent on RAM requiring approximately five times the image size in order to run smoothly. RAW conversion software also relies on being able to display and quickly update full-sized previews so the demands placed on RAM are very high.

RAW A generic term for the many proprietary file formats that are produced by different manufacturers' digital cameras. A RAW file contains the raw sensor data and is accompanied by a set of parameters which remains flexible and can be altered using RAW conversion software.

RGB A colour mode where all the colours within an image are made up of red, green and blue. RGB is the most commonly used colour mode for digital cameras, home printing and screen display.

Resampling Changing an image's resolution by either removing pixel information and thus lowering the resolution, or by adding pixels via interpolation thus increasing the resolution of an image.

Resolution Either the absolute number of pixels that an image contains or that a sensor can capture – see megapixel – or the number of pixels that can be

printed or displayed over a certain distance, typically the number of dots or pixels an inch. In the later case resolution is only relevant in relation to the print or display size.

Saturation The intensity of a particular colour, the more saturation the more intense the colour. An image with no saturation will be rendered greyscale. Saturation can typically be altered in RAW conversion software via a slider or series of sliders.

Sharpening The application of increased contrast in order to create the illusion of an image being crisp.

Slider A tool that is commonly used in many RAW conversion programs to make alterations to variable parameters such as contrast and saturation.

sRGB A colour space that is narrower than Adobe 1998 RGB, but is commonly used for display on computer monitors and output through home printers.

Thumbnail A low-resolution preview image of a larger image file, used to check what the image is before open the full-sized file. These are used in many browsers to enable you to scroll quickly through a number of images.

TIFF Tagged image file format. A format that is widely used by professionals as it is compatible with the vast majority of programs on both Macs and PCs and can be archived as it does not use compression.

Underexposure Either rendering an image darker than it should be by allowing too little light to strike the sensor, or the complete loss of shadow information through tones being rendered too dark to be captured with detail by the sensor. The first is correctable, but the second is not.

USM abbreviation for unsharp mask, a process where the image is sharpened using the unsharp mask filter in Photoshop.

Vibrance A so-called 'intelligent' saturation tool that seeks to enhance only those parts of the image for which it is appropriate.

White balance The in-camera function that allows compensation for different colour temperatures. This is also a function that can be access through most RAW conversion software.

Workflow The process from prior to the intial capture, to the archiving of the final file.

Useful contacts

Calibration

ColorVision
Colour calibration products
www.colorvision.com

Gretag MacBeth
Colour calibration products
www.gretagmacbeth.com

International Color Consortium
Information about colour calibration
www.color.org

Photographer

Andy Rouse
Author's website with stunning image collections, a
lively blog and an online store where you can buy
signed books and prints
www.andyrouse.co.uk

Photographic equipment

Canon
Cameras, accesories and printers
www.canon.com

Epson
Printers and accessories
www.epson.com

Nikon
Cameras and accesories
www.nikon.com

Olympus
Cameras and accesories
www.olympus.com

Pentax
Cameras and accesories
www.pentaximaging.com

Sandisk
Storage cards
www.sandisk.com

Sony
Cameras and accesories
www.sony.com

Publisher

Photographers' Institute Press
Practical photography books as well as *Outdoor
Photography* and *Black & White Photography* magazines
www.pipress.com

Software

Adobe
Photoshop, Photoshop Elements, Photoshop Lightroom,
Adobe Camera RAW and information about the digital
negative file format
www.adobe.com

Apple
Apple Aperture.
www.apple.com

Extensis
Various Photoshop plug-ins.
www.extensis.com

Noise Ninja
Noise-reduction plug-in
www.picturecode.com

Photo Mechanic
Image browser
www.camerabits.com

Picasa2
Free DAM software
http://picasa.google.com/

About the author

Andy Rouse is a world-renowned professional wildlife photographer who just loves animals. Passionate about conserving both species and their habitats, he has set up his own conservation fund and this year sees the launch of his worldwide exhibition on climate change. His images are published around the globe in advertising, the media and calendars. Equal to his passion for conservation is his love for photography, and he has been involved in RAW software industry for many years. He is not a self-professed technical guru nor does he want to be one; he just knows about what matters: how to get the best out of his images for his demanding clients. He has written 12 books to date and is an inspirational speaker whose programme of annual theatre talks is in high demand. He is a multi-award winning photographer with consistent success in the BBC Wildlife Photographer of the Year competition. And he does all this with a smile on his face, as he believes photography is about having fun. For more visit www.andyrouse.co.uk

Index

Photographers' Institute Press, an imprint of The Guild of Master Craftsman Publications Ltd, 166 High Street,
Lewes, East Sussex BN7 1XU
Tel: 01273 488005 Fax: 01273 402866
www.pipress.com